Moments in Jewish Life

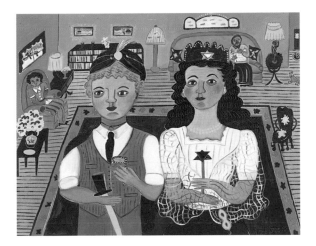

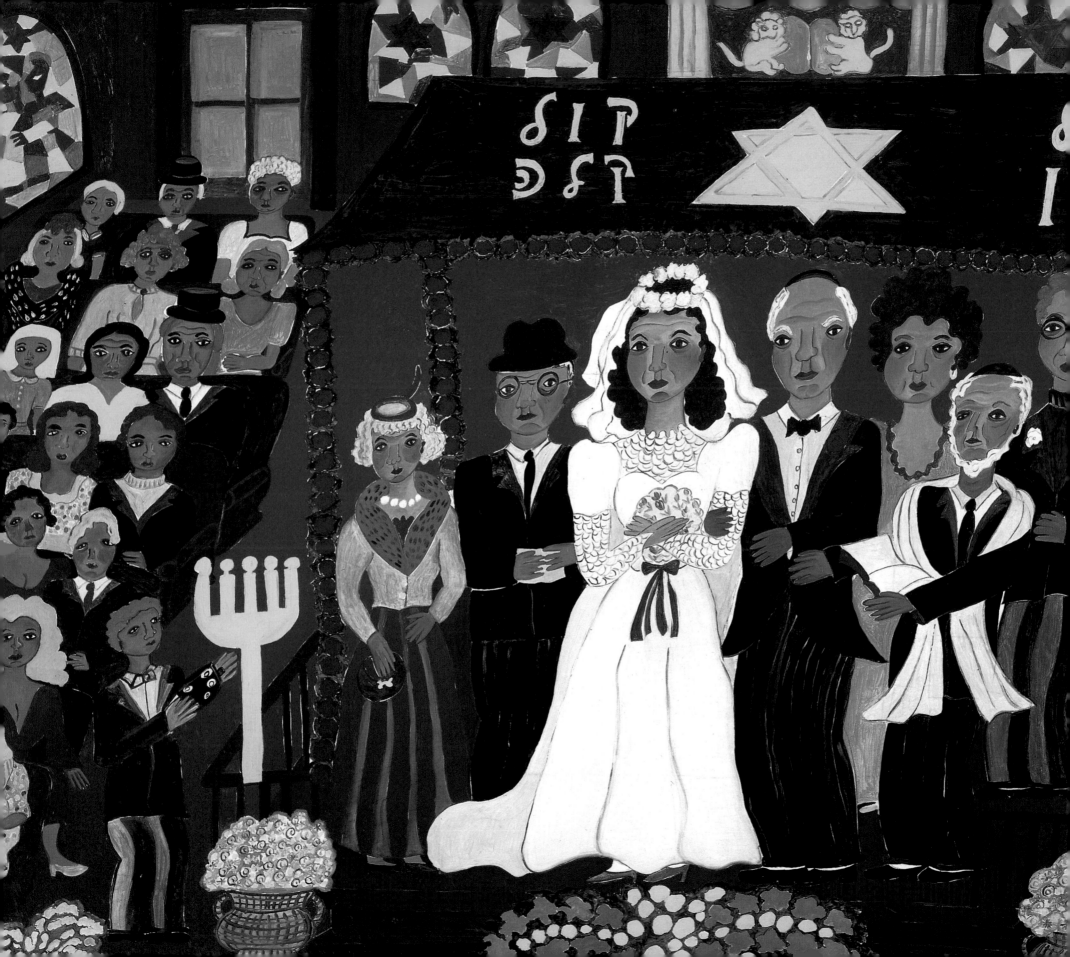

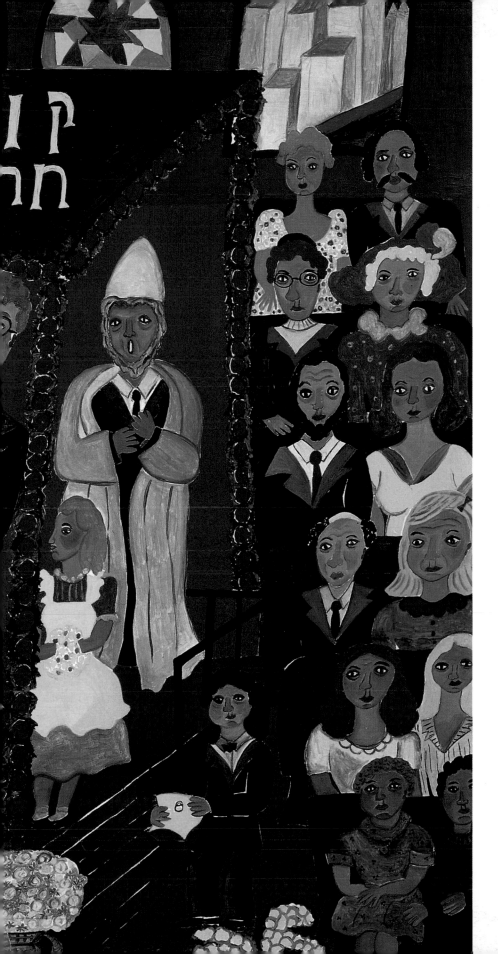

Moments in Jewish Life
The Folk Art of Malcah Zeldis

Text by Yona Zeldis McDonough

FRIEDMAN/FAIRFAX
PUBLISHERS

A FRIEDMAN/FAIRFAX BOOK

© 1996 by Michael Friedman Publishing Group, Inc.

Library of Congress Cataloging-in-Publication data available upon request.

ISBN 1-56799-368-0

Editor: Sharyn Rosart
Art Director/Designer: Jeff Batzli
Photography Editor: Wendy Missan
Production Director: Karen Matsu Greenberg
Paintings © Malcah Zeldis
Principal photography: Bob Sasson

Color separations by Ocean Graphic International Company Ltd.
Printed in China by Leefung-Asco Printers Ltd.

For bulk purchases and special sales, please contact:
Friedman/Fairfax Publishers
Attention: Sales Department
15 West 26th Street
New York, New York 10010
212/685-6610 FAX 212/685-1307

CREDITS

Collection of the Artist: 1, 5, 6, 8, 28, 31, 32, 36, 37, 40, 45, 48–49, 51, 53, 58, 64, 67, 69, 70–71, 72, 75, 77, 79, 84, 85, 89 Corporate Collection; triptych created with the support of the Memorial Foundation for Jewish Culture Award: 11–14 Creative Heart Gallery, Winston-Salem, NC: 80 Collection of Dr. and Mrs. Eric M. Goldberg: 35, 38–39 Collection of Sussan Goldstein: 27 Collection of Dr. and Mrs. David Kliot: 16 Collection of Annette Miller: 68, 81 Museum of American Folk Art: 26 New York State Historical Association, Cooperstown, NY: 17, 18–19 Noyes Museum, Oceanville, N.J.: 2–3, 83 Private Collection: 24, 29 Collection of Mr. and Mrs. Shlomo Sayegh: 63 Skirball Museum, Los Angeles, CA: 20, 22-23 Toad Hall, ABC Home, New York, NY: 57, 59, 60 Yeshiva University Museum, New York, NY: 46

Visit the Friedman/Fairfax Website:
http://www.webcom.com/friedman

DEDICATION

For the Sayeghs—Alia, Shlomo, Joe, Abby and Sharon—my other family
—**Yona Zeldis McDonough**

For my friend Lee Cogin, whose support is deeply appreciated
—**Malcah Zeldis**

ACKNOWLEDGMENTS

I would like to thank my editor, Sharyn Rosart, for her enthusiasm and general good humor throughout the completion of this project, as well as my former teachers Pamela Askew and Kenneth E. Silver, both of whom taught me the grammar of "reading" paintings. Finally, I would like to thank my mother, Malcah Zeldis, for inviting me into her marvelous pictorial world.
—**YZM**

My heartfelt thanks and appreciation to Yona, who worked so quickly and efficiently (while pregnant with her second child) to make this book a reality; and to Leonard Marcus, for his help, inspiration, and patience. I would also like to thank everyone at Friedman/Fairfax, including Wendy Missan, Jeff Batzli, and Sharyn Rosart.
—**MZ**

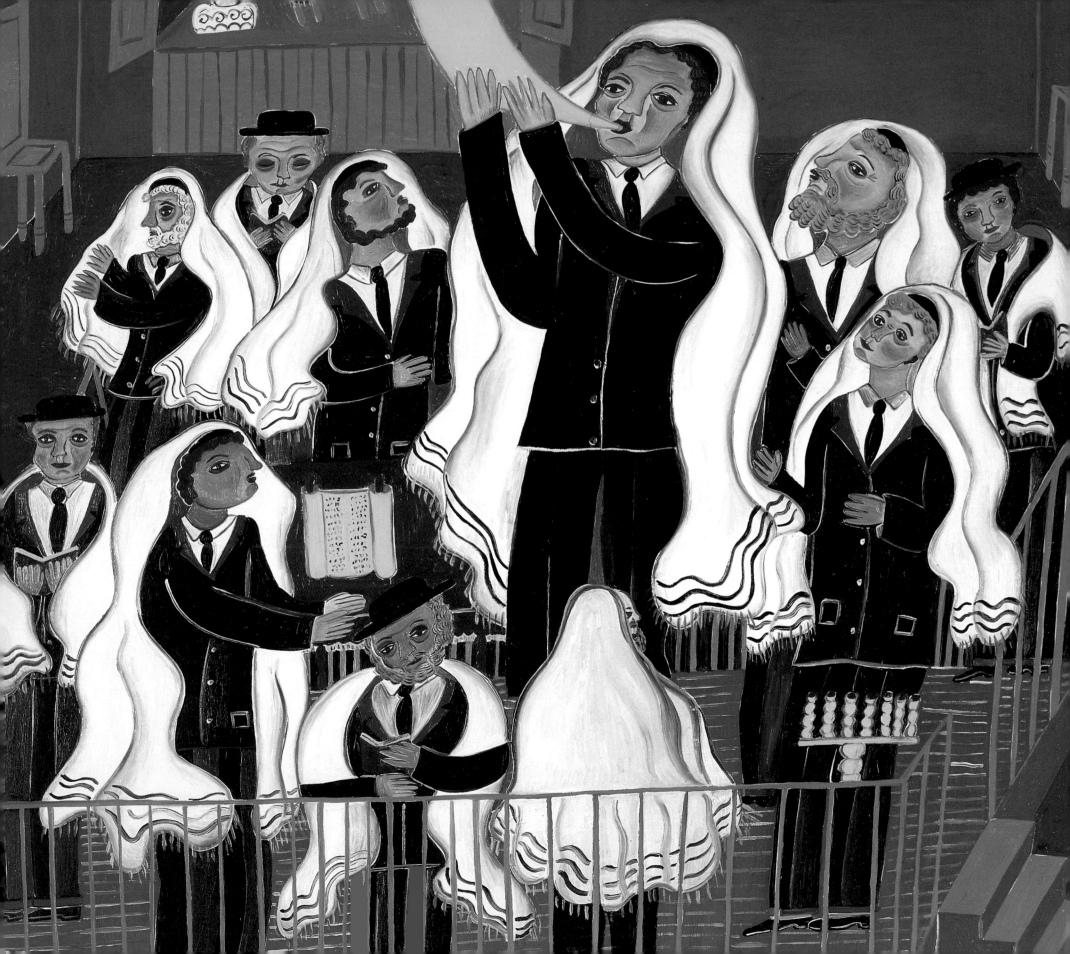

Contents

Opposite: detail from **Blowing the Shofar**

FOREWORD

In an exuberant style, Malcah Zeldis has captured the vigorous spirit and aesthetic beauty of Jewish religious observance and practice in both the home and the synagogue. Her personal memories centered around family and neighborhood life extend through a broader framework built within the context of the emigration of her family in the early twentieth century from the shtetls of eastern Europe. The paintings resonate with an authenticity that is both convincing and deeply moving.

Malcah Zeldis' compositions are presented in a familiar style punctuated by deeply saturated color; the works are representational yet highly abstract. Her visual narratives, compressed and layered in a shallow picture plane, are richly detailed and burst with energy.

The accompanying text by the artist's daughter Yona Zeldis McDonough—richly interlaced with quotes from the artist—complements the colorful images and provides a balanced counterpoint to the lively artworks.

The artist's optimistic life view combined with respect and reverence for her heritage have applications to people of all faiths and ethnicities and speak to the splendid diversity of American culture.

—LEE KOGAN
DIRECTOR, FOLK ART INSTITUTE,
MUSEUM OF AMERICAN FOLK ART
NEW YORK, NY

PREFACE

The Jewish calendar is replete with meaning; from day to day, week to week, month to month, and year to year, there are festivals, symbols, rituals, traditions, and holy days—and holy ways of honoring them. In this book, a mother and daughter collaboration, we invite you to enjoy a collection of remarkable paintings, and through them, to understand, participate in, and celebrate the special moments that make the Jewish faith what it is today.

My mother, Malcah Zeldis, is a renowned folk artist whose work provides a unique perspective on Jewish life and customs. Her original and idiosyncratic vision is expressed in a harmonious synthesis of color, form, pattern, and line. Midrash—the interpretation of texts—has long been a staple of Jewish thought and study; here, the midrashim are the images themselves, as they attempt to extract what is most significant and sacred from the cycle of Jewish observance and worship.

Relying on memories and recollections of Jewish life in many contexts, Malcah re-creates and refashions her observations to form a dense, richly colored world that is universal in its appeal while remaining true to the authenticity of its creator's own experiences.

It is our hope that in reading about the sacred moments of Jewish life and looking deeply into these evocative paintings, readers will find meaningful echoes of their own experience of Jewish life.

—YONA ZELDIS MCDONOUGH
NEW YORK, 1996

INTRODUCTION

Ever since the destruction of the Second Temple in 70 C.E., the history of the Jews has been one of exile, movement, and wandering—in short, the Diaspora. Sent forth from their ancient homeland of Israel, Jews have found their way to every corner of the earth, carrying with them their unique customs, traditions, and modes of experience. In modern times, the exodus that springs immediately to mind is the one that took place in the latter part of the nineteenth and the early part of the twentieth centuries. This, of course, is the massive influx of Jews from the shtetls of Eastern Europe—Russia, Poland, Romania, Hungary—to the bright, if sometimes terrifying, shores of the New World.

For Malcah Zeldis, a first-generation American whose parents emigrated from Russia in the early twentieth century, the awareness of what was left behind was never far from consciousness, and in her work, this theme is repeated over and over.

The triptych *Family Saga* devotes an entire panel, "Europe," to life in the Old Country; according to the painter, this panel's subtitle could have been "War and Peace." At the top of the painting are terrifying images of brutal violence: houses on fire, armed Cossacks stampeding into Jewish towns and villages, and dead bodies lining the streets. A prominently featured church is part of a haunting recollection of Malcah's own mother, who recalls being hidden there as a child during a pogrom: "My mother says that she still remembers the face of the priest who risked his life to give her family shelter."

The bottom part of the panel is devoted to the more idyllic aspects of village life: market stalls, weddings, houses, and farms. A building whose fourth wall is invisible, revealing the beds and bureaus within, represents the inn run by Malcah's maternal grandmother during a period when her husband toiled in America to earn money for his family's passage. In the center, a small boy being carried toward a *heder* represents Malcah's father on his first day of school. "Being carried was considered an honor," she explains.

Opposite: detail from **FAMILY SAGA**, *Panel One, "Europe"*

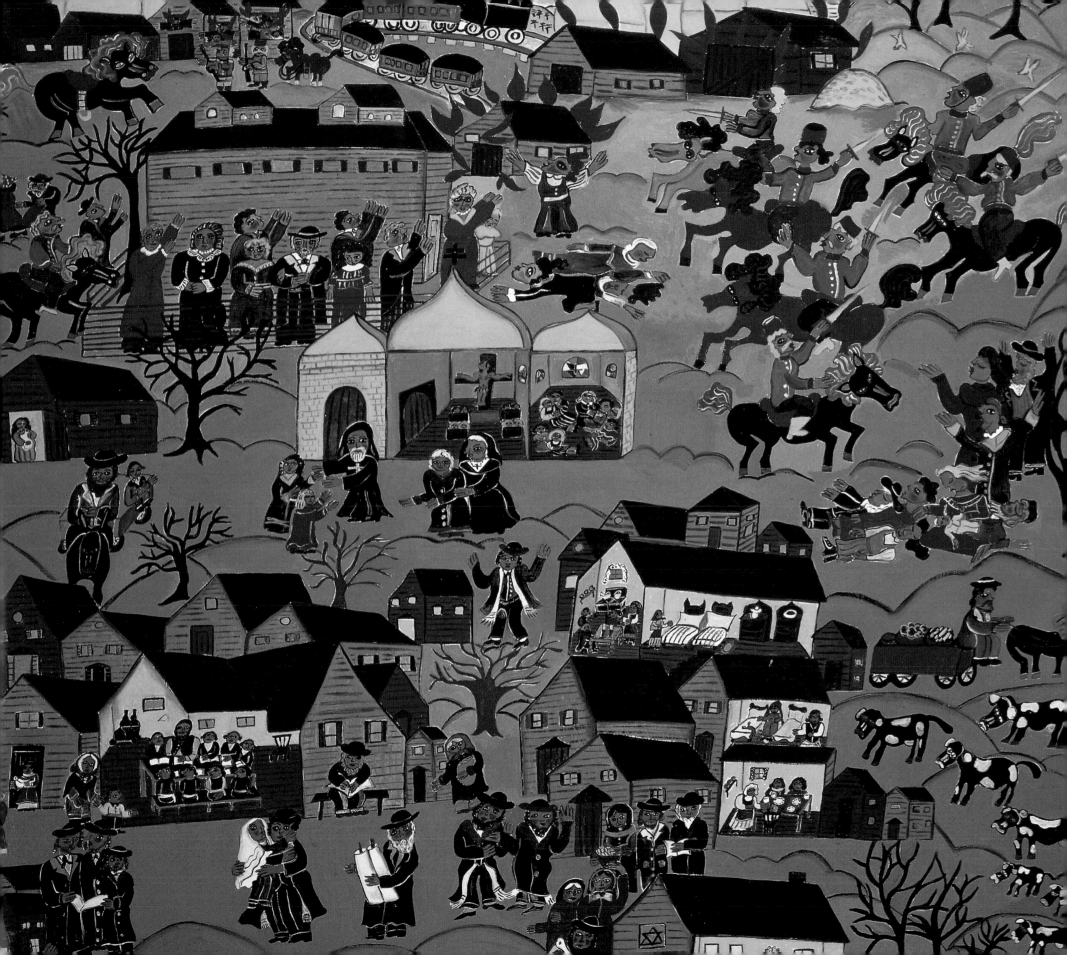

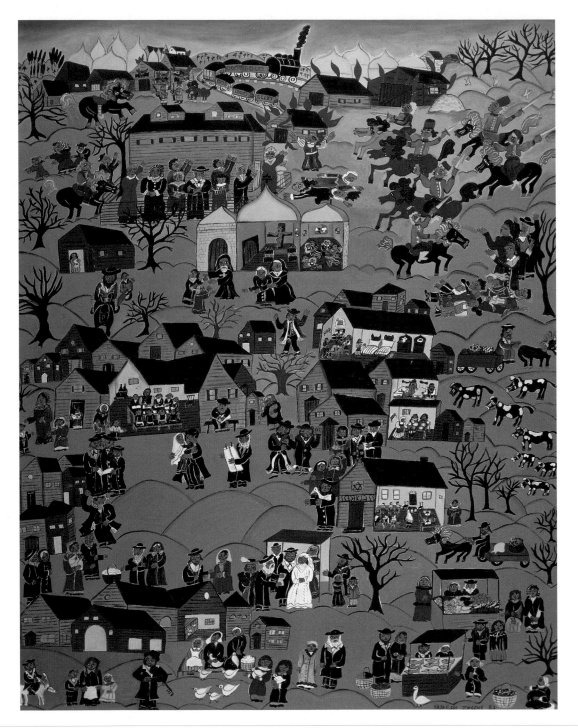

FAMILY SAGA, *Panel One, "Europe"*

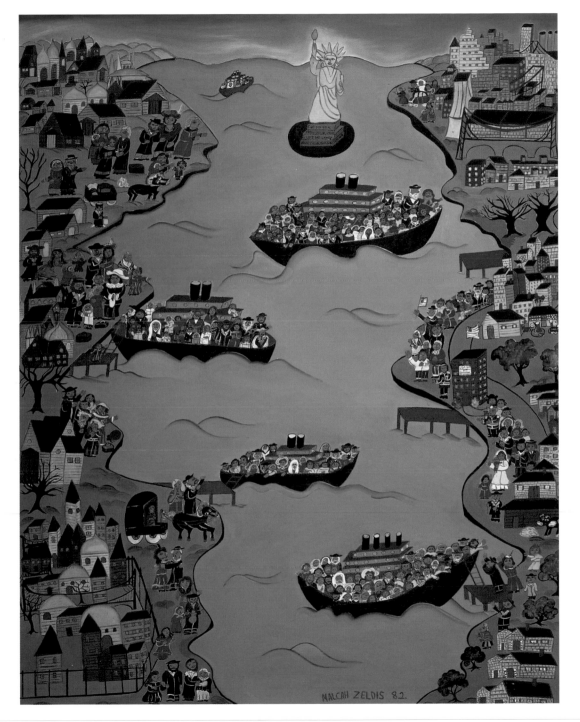

FAMILY SAGA, *Panel Two, "The Crossing"*

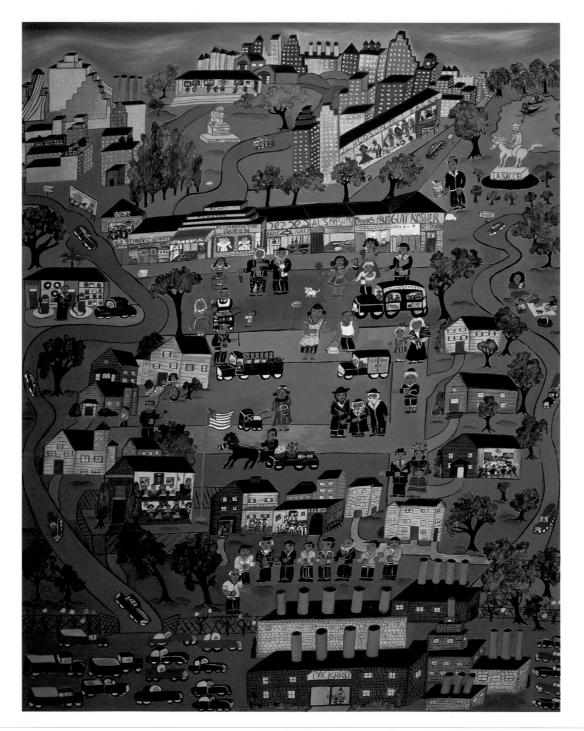

FAMILY SAGA, *Panel Three, "Detroit"*

The central panel of the triptych, "The Crossing," shows the journey to America. The turquoise waters are filled with crowded boats of Jewish refugees. The Statue of Liberty, shining and benign, holds her lamp aloft to welcome the weary voyagers. At the left are the villages and towns of Russia. At the right, the shores of America; New York City, with its bridges and skyscrapers, appears at the top left. "My father and mother met in New York," says Malcah. "That's where they courted and married."

The third panel, "Detroit," shows the city where the artist's parents eventually moved to raise their family. At the top is the Detroit Institute of Art, the city's free museum, where a poor immigrant worker could take his family on a Sunday outing. "In part, my being an artist comes from those early visits," says Malcah. "I'll never forget the power those paintings had to move me as a child." Jewish shops and stores line the streets of the neighborhood; we see a kosher butcher shop and signs in Yiddish. Below is the Packard factory, where Malcah's grandfather worked, assembling automobiles. Eventually, Malcah's father had a job there—one of the many he held—as a night watchman.

In the painting *Delmar Avenue, Detroit* (page 16) the street of Malcah's childhood home is brought into focus. At the back is Oakland Avenue, the central commercial street of her neighborhood, and in the foreground is Delmar Avenue itself, vividly rendered in blues, greens, and reds. The man in the foreground with the watermelon cart represents the artist's father, a resourceful man who did anything he could to provide for his family, including peddling fruit, ice, and Christmas trees, and working as a plumber, electrician, and housepainter. An ice cream truck represents the happy aspects of childhood for the artist.

Hank Greenberg (page 17) is another painting of Delmar Avenue. It depicts the artist's family seated around a table on a porch, playing cards and listening to the large radio on the windowsill. The radio broadcasts a baseball game in which the Jewish player Hank Greenberg is playing; we know this because of the stadium that appears directly above the seated group. Smiling and handsome, the iconlike Greenberg looms large over all the other figures and indeed all the figures in the painting. His prowess and his talent are talismans for the important immigrant Jews who are still shaky about their status in the New World. "There was always a kind of insecurity about being Jewish in my family," the artist explains," the traumas inflicted by life in Europe left their scars. Hank Greenberg was a kind of savior; it was as if his triuphs would protect even humble Jews from the terrors of anti-Semitism."

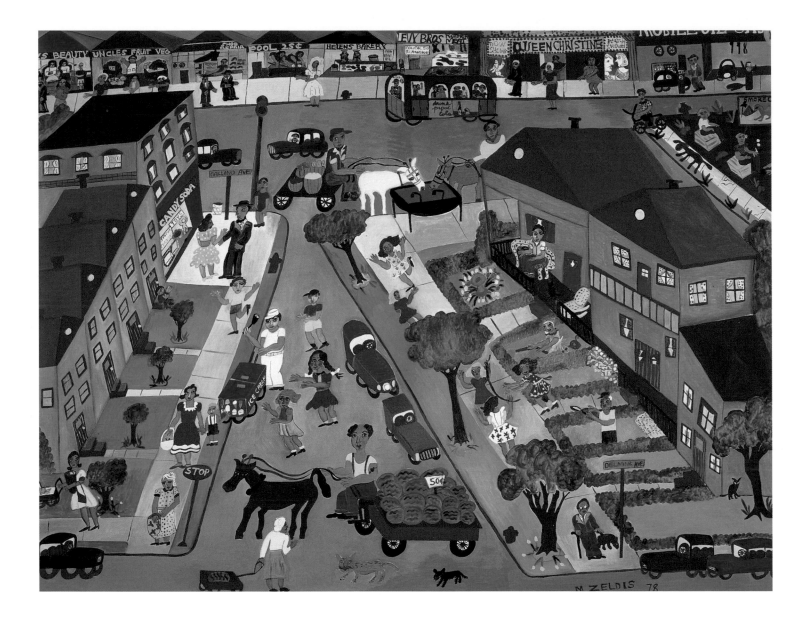

DELMAR AVENUE, DETROIT

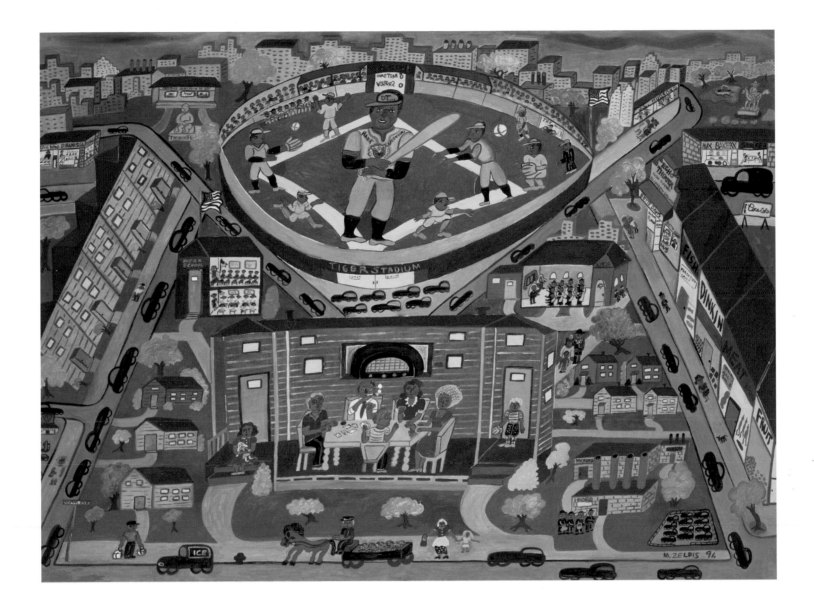

Above: **HANK GREENBERG**

Overleaf: detail from **HANK GREENBERG**

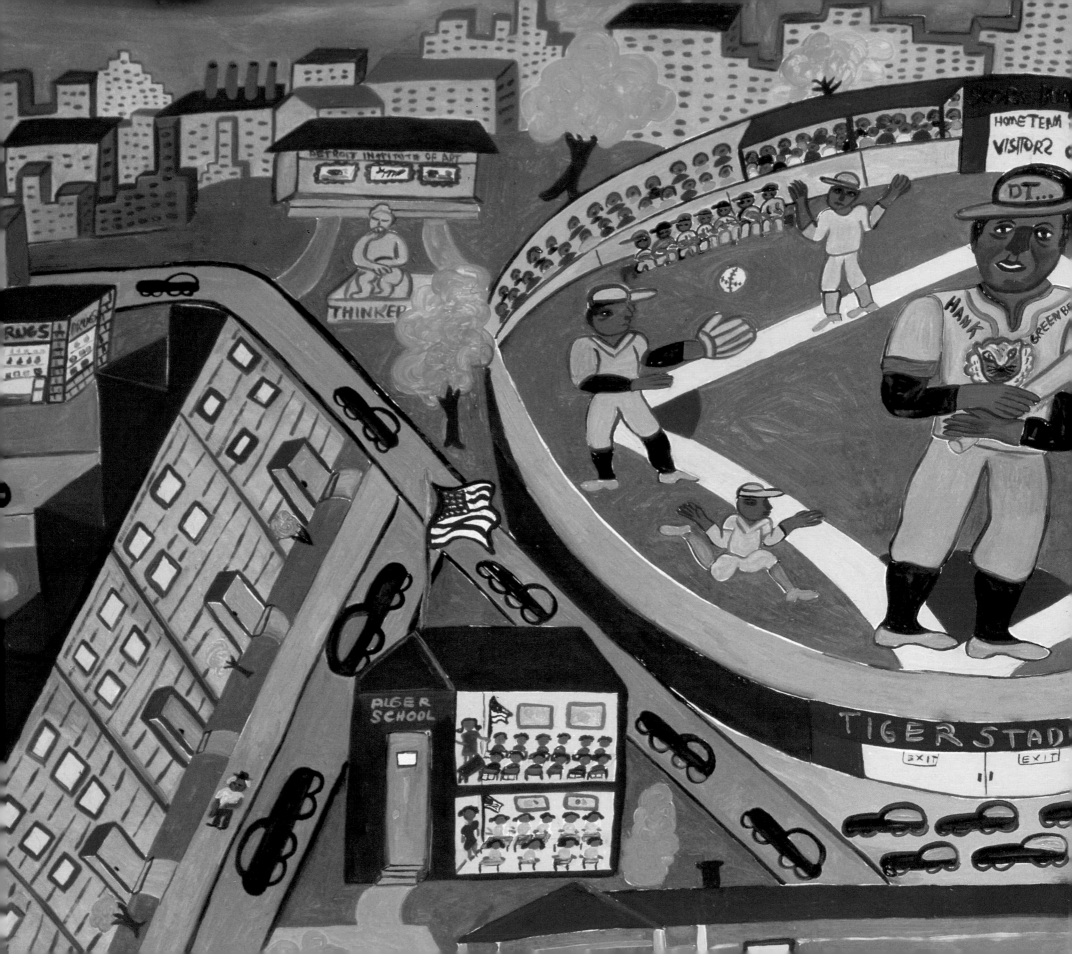

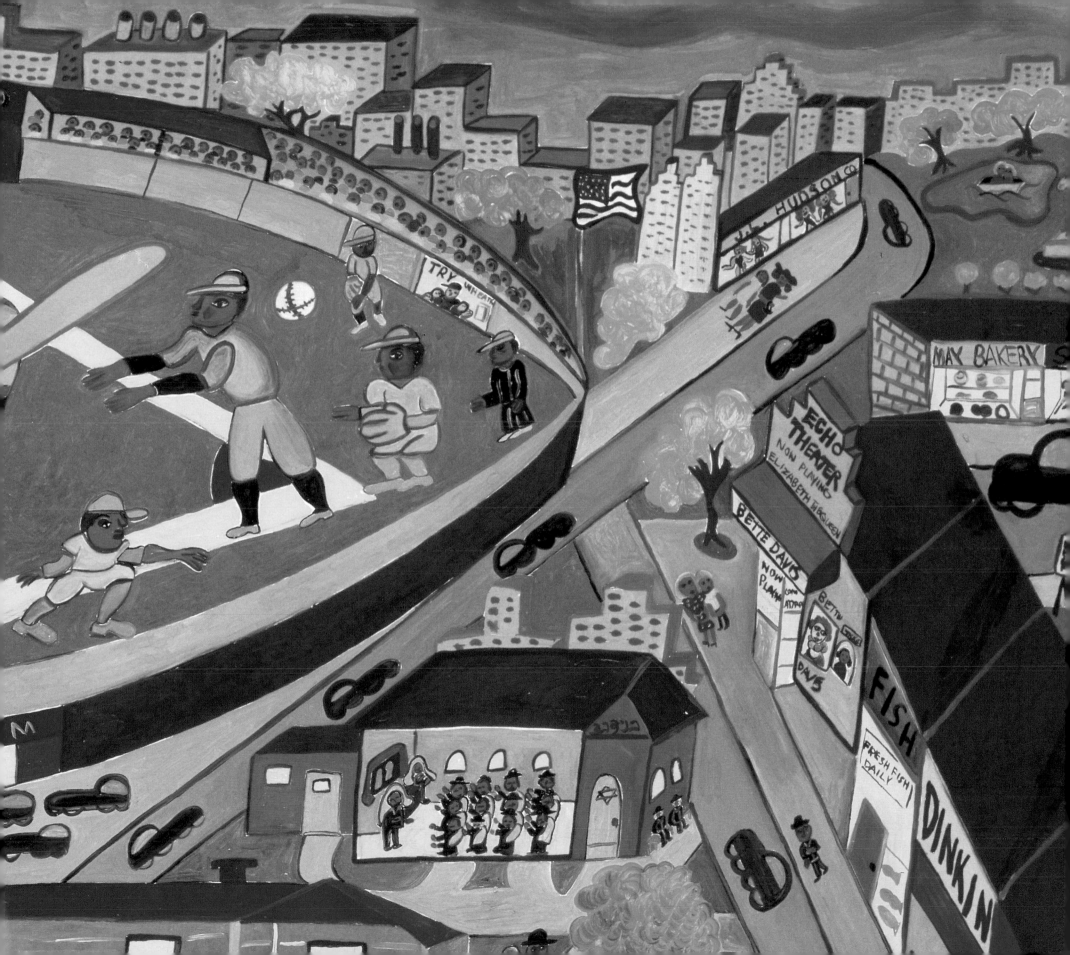

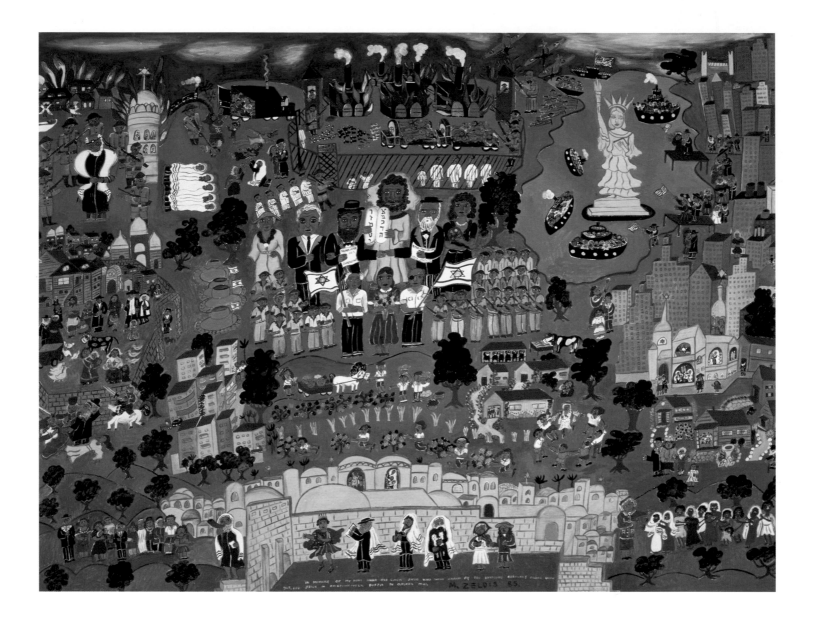

In *Generations*, the imagery of the journey seen in the triptych *Family Saga* has been compressed into a single painting. Here, strife-torn Europe appears at the left, and the Statue of Liberty and the buildings of New York share the space at the right. The top central portion of the painting shows the flames of the crematoria in the Nazi death camps; here, the artist is referring to the tragic fates of her mother's sister and nephew, who were gassed when the Germans invaded Russia. Tiny pink houses and children playing ring-around-the-rosy represent Detroit, scene of Zeldis's more peaceful childhood.

A unique feature of this painting is the depiction of modern-day Israel, where the artist lived for nine years as a young woman. Biblical figures share the stage with people such as Moshe Dayan and Golda Meir. The artist and her mother are there as well, on a pilgrimage to the Western Wall in Jerusalem. At the bottom right, Golda Meir is shown bringing the Jews of Ethiopia—the Falashas—into the promised land. "I heard that this was happening and found it so touching that I had to include it," explains Malcah.

Seen together, these paintings provide a wonderful backdrop for the ones to come as you read further, for they stress the theme of the journey, which has been central and formative to the Jewish experience. One of the results of this constant movement has been that in each culture where Jews have lived and thrived, they have reshaped their customs to suit their new homelands.

In his book *The Chanukah Lamp*, Mordecai Narkiss states, "Lamps underwent all the adventures of their owners....Like their owners, they are products of their environment and their period, and like their owners, they would derive from their environment whatever could be taken and would combine it with the traditional form and function, thereby digesting and Judaizing the foreign elements." This description could be extended to virtually all Jewish customs, which were creatively reinvented in the new lands where Jews now practiced them.

This is the basis of Malcah Zeldis's interpretative mode—the blending of the old and the new, as they came together in the rituals of her childhood. In her work, we see how the gentle, age-worn customs of Europe survived and were redefined by the bracing air of America, and how the artist, in turn, used both old and new to create her unique interpretation of the traditional Jewish ways. For the many Jews whose family experiences echo Zeldis's, these images will call up familiar memories.

Overleaf: detail from **GENERATIONS**

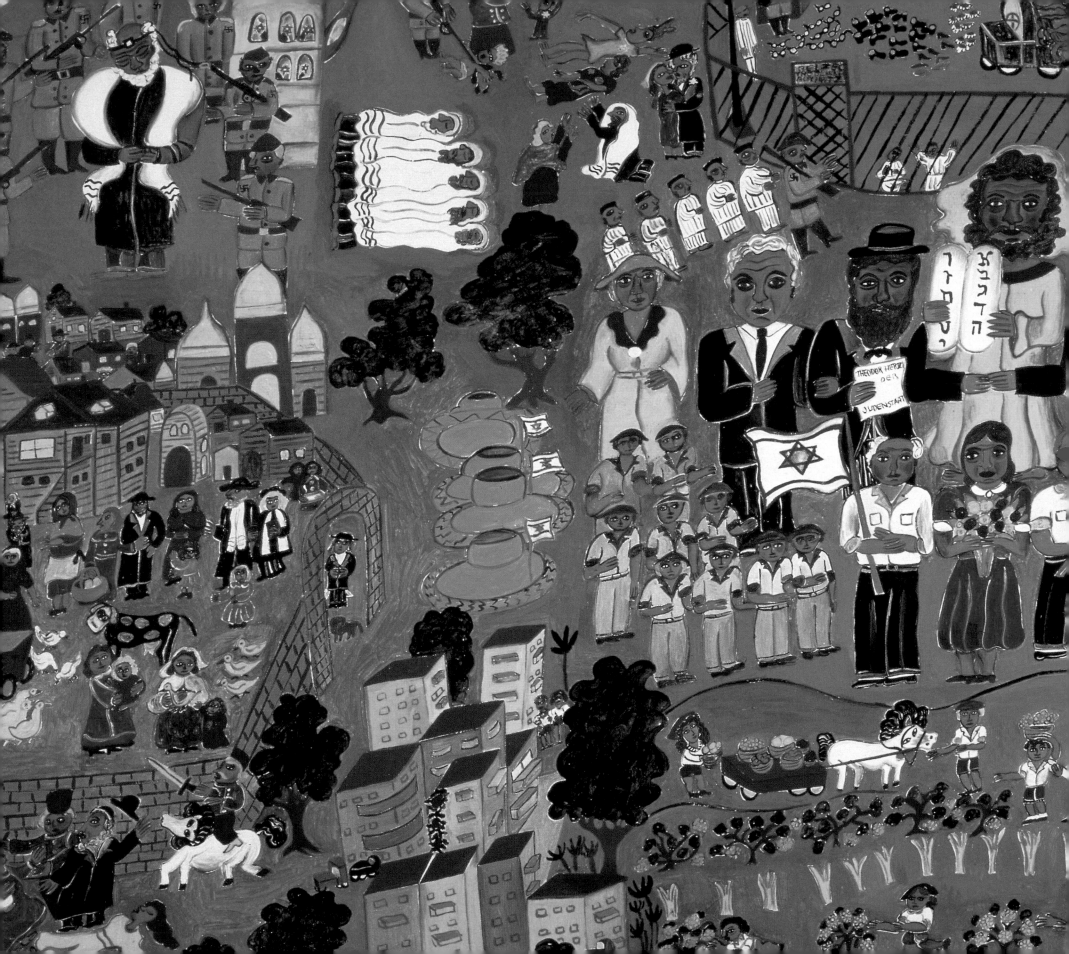

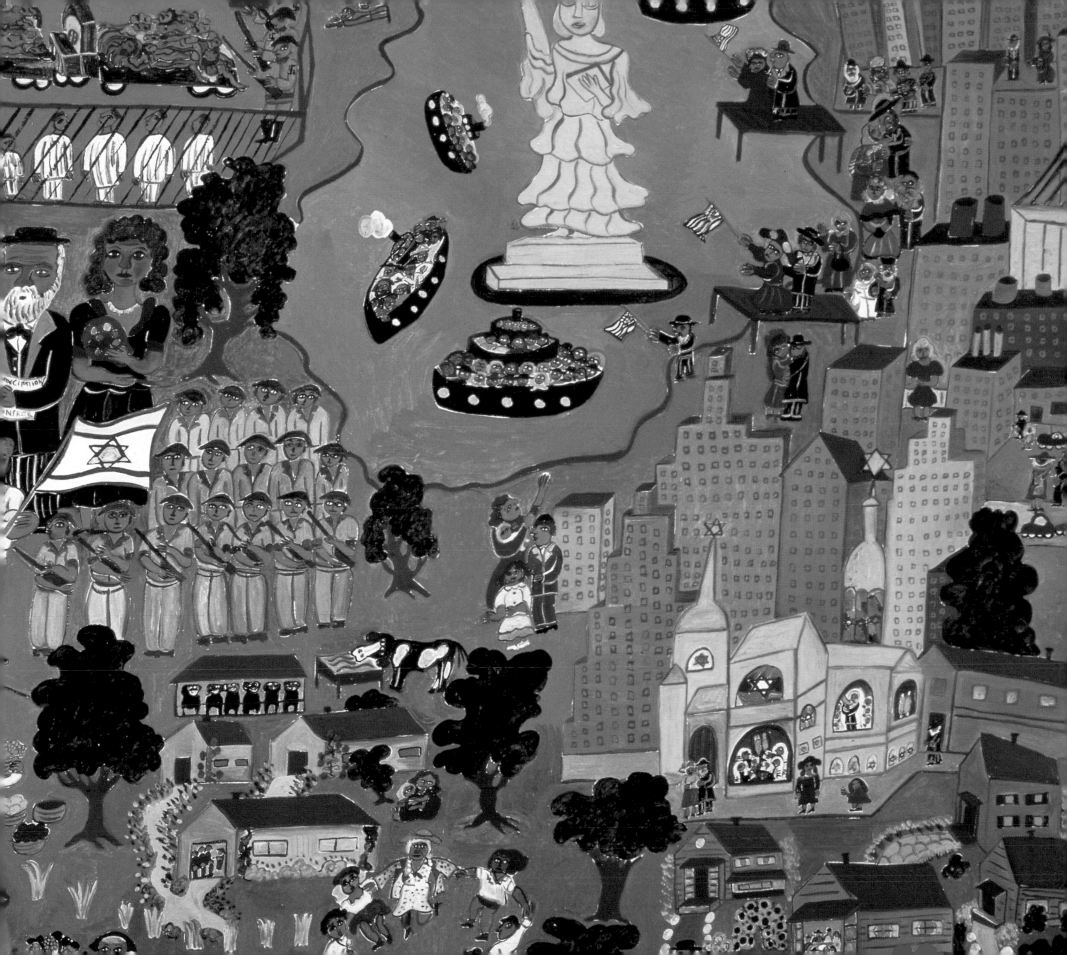

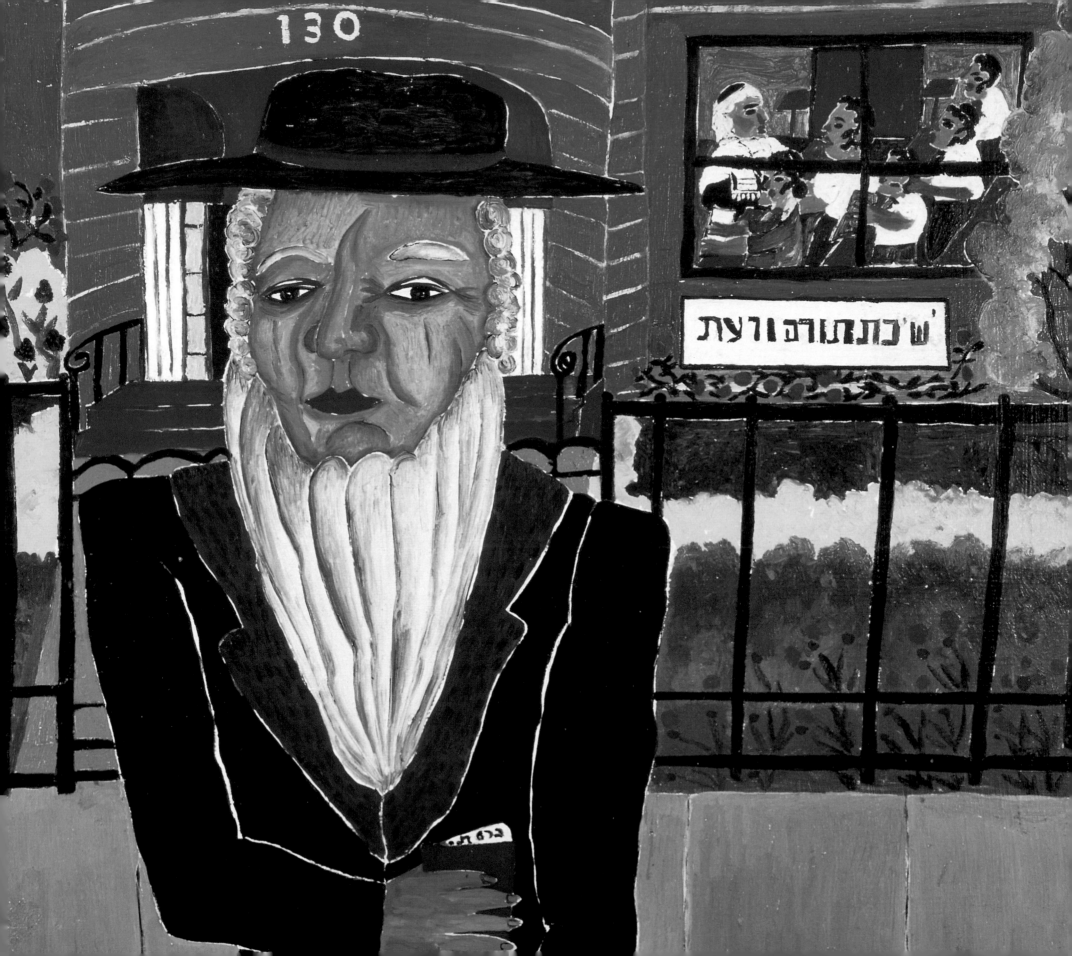

THE FABRIC OF OBSERVANCE:
DAILY LIFE IN THE JEWISH WORLD

Many of Malcah Zeldis's Jewish images do not pertain directly to a specific holiday or celebration; they describe—in her vivid, emotional style—her responses to the daily aspects of Jewish observance and ritual. Like her paintings of the holidays and festivals, these paintings draw on a number of sources for their inspiration, including her childhood memories and her experiences as a wife and mother living in various Jewish neighborhoods in Brooklyn, New York.

In *Shul* (page 26) shows her grandfather's synagogue in Detroit, with a group of men holding the Torah. As is often the case, her grandfather appears, this time as the bespectacled figure wearing a hat in the upper right-hand corner. "The Jewish services have always appealed to me," says Malcah of this painting. "Their seriousness, their commitment, and their passion have been deeply instructive. In this painting, I felt as if these men were literally handing over the traditions of their fathers, and their fathers' fathers, to me, the artist who would record them for posterity."

In *Man Donning Tallit* (page 27), we are privy to that sacred moment when the ritual prayer shawl—white, flowing, swirling with a spiritual energy all its own—is being put on. Unlike the more public *In Shul*, this is an intensely private image, for we are in the man's own bedroom—his unmade bed appears to the left, and next to it are a lamp-topped night table and two bureaus. In the room beyond is an apron-clad woman, presumably his wife. A small girl holding a doll watches from behind. Perhaps she is unseen by the man, who seems to be engrossed in his ritual activity. This child, as we have come to see, is the artist; here, she looks longingly at a ritual in which she is barred from participating. "But to paint someone putting on a *tallit* is my way of getting to wear one," says Zeldis. Indeed, it is the wonderful and even subversive nature of her art that allows the artist to assume a variety of guises simultaneously; in this case, she—and we—share the experiences of both the child watching and the man doing.

Opposite: detail from **RABBI AND YESHIVA**

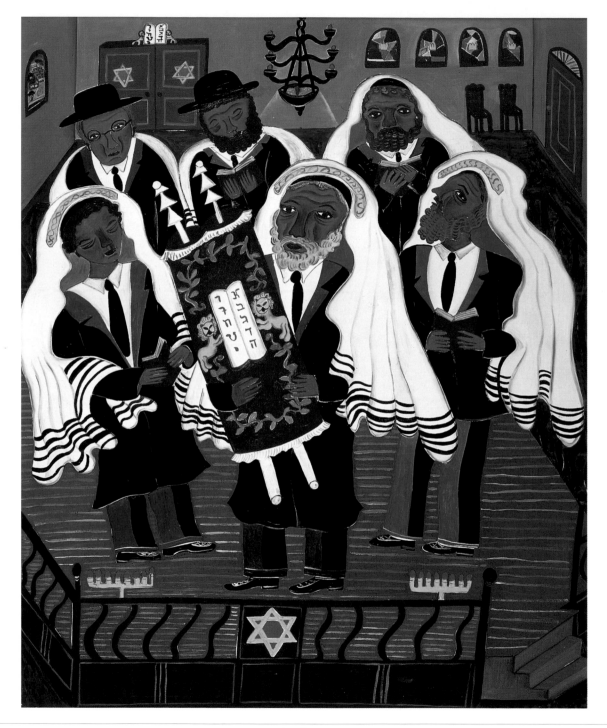

IN SHUL

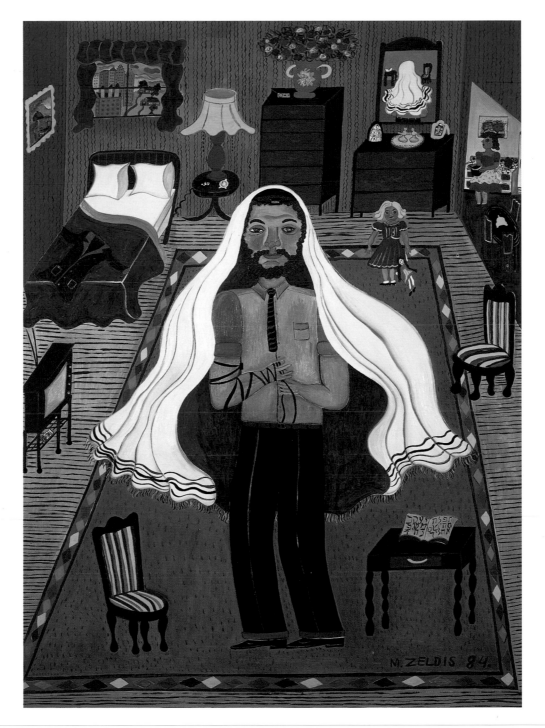

MAN DONNING TALLIT

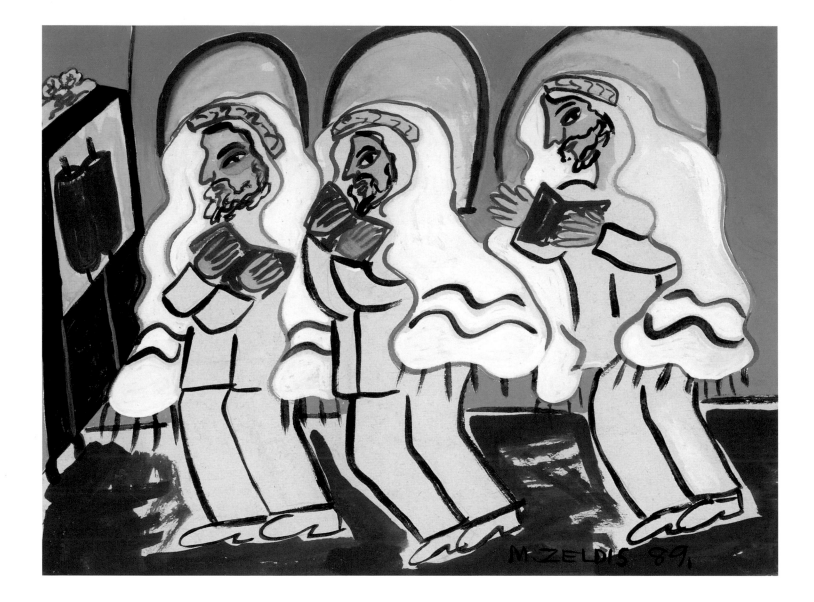

DAVENING

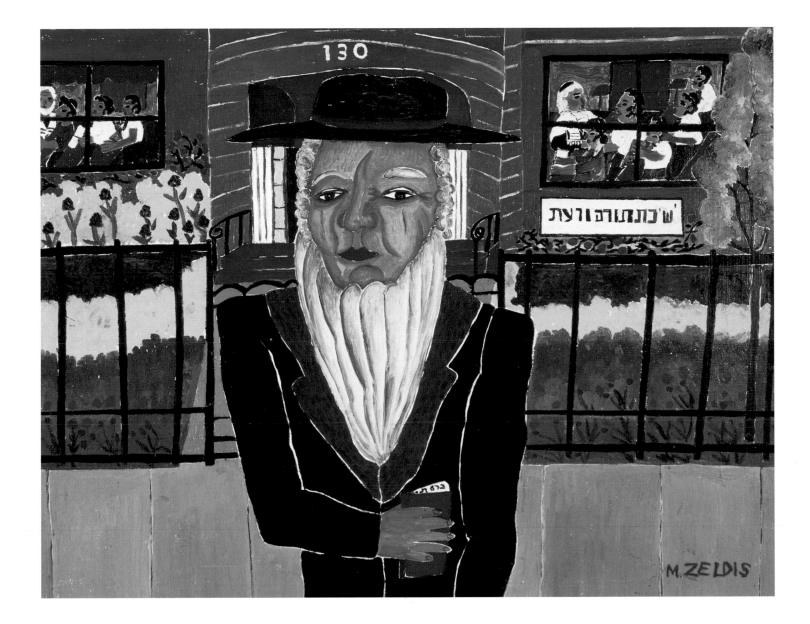

RABBI AND YESHIVA

The motif of the *tallit* is again explored in *Davening* (page 28), which shows a group of men at prayer. Once again, the shawls worn by the men offer a startling visual equivalent for the profound spiritual energy and passion involved in the communal activity of prayer. The three *tallitot* are painted in a bold, fluid manner; their wild, gyrating lines animate an otherwise static group of figures. Even the fringes at the edges of the *tallitot* seem to bristle with energy.

Rabbi and Yeshiva (page 29) offers a wholly different image of religious devotion. Where *Davening* is loose and wild, this painting is controlled and even geometric in its organization. The rabbi is held firmly in place by the rectangular doorway in front of which he stands, and the picture is broken up into a series of rectangles and squares: the pavement of the sidewalk, the fence railings, and the windows. The serious, lined face of the central figure, the vibrant yellows, reds, and peacock blue of the palette, and the flowers that are near the fence all suggest a different—but no less intensely felt—form of spiritual observance.

"We used to live in an apartment at 140 Ocean Parkway," explains Malcah. "This yeshiva—really no more than a tiny private house converted to a school—was right next door at 130. I used to see the boys at study and hear the sounds of their chanting. I watched the rabbis come and go. I admired their utter devotion to that life and wanted to paint an image of that." Certainly, this painting—iconic, formal, composed—is a brilliant fulfillment of that aspiration, and a great Jewish portrait of the twentieth century.

Thirteenth Avenue is another image drawn from the Zeldis family's life in Brooklyn. In it, we see a bustling working-class neighborhood where she used to shop. A fish market and an Italian bakery are on the corner; the Poor People's market is situated behind a community garden. But the real impetus for the painting came from the ritual slaughterhouse—the oldest one in Brooklyn at the time and now long gone—at the left, which serviced the many Orthodox Jews who lived in the area. Zeldis has long admired the foundations upon which the *kashrut* laws are based: concepts of mercy and purity that extend even to food, and which are part of an entire picture of life.

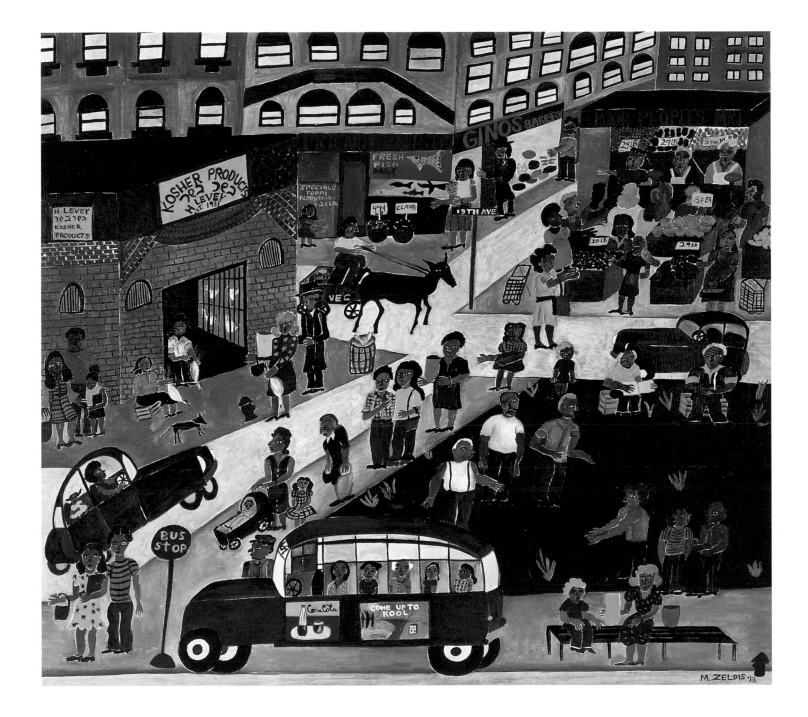

THIRTEENTH AVENUE

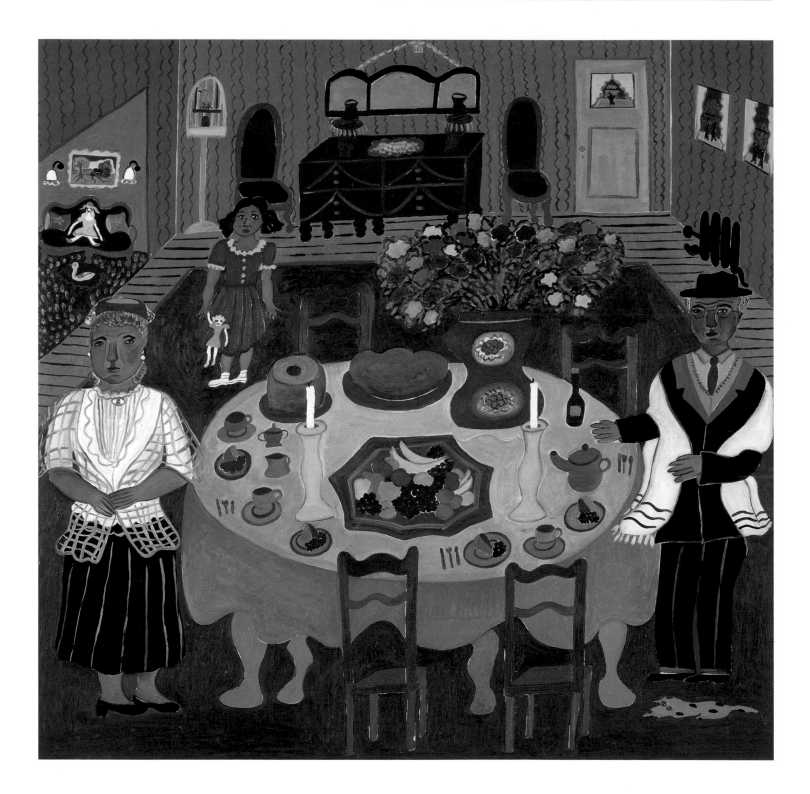

SHABBAT: THE CORNERSTONE OF JEWISH EXPERIENCE

Underlying the myriad and beautiful Sabbath rituals observed by Jews the world over is a philosophy: that of democracy in action. In the ancient world, each day was seen as a workday. Men, women, children, and animals toiled seven days a week, without cease or rest. The concept that one day of each week should be set aside for physical rest and spiritual rejuvenation was a radical one that was initially regarded with hostility by the pagans, who viewed their Jewish neighbors as lazy and slothful.

Not only did the keeping of the Sabbath compel employers to give their workers a day of rest, but its influence extended to the home. Women, who in ancient times worked as long and as hard as many slaves, were also liberated from their daily chores by the observance of Shabbat. Even the beasts of burden—donkey and ox—were granted a reprieve on this holy day. Thus, the Jewish Sabbath became a holiday in which all could participate and celebrate.

Shabbat begins at sundown on Friday, and traditionally, extensive preparations are made beforehand. The house is scoured, and a lavish meal prepared in advance, for the "kindling of fire" is among the thirty-nine activities specifically forbidden on this day. The Sabbath table is laid with great care, as can be seen in *Full Table*. Here, the artist recalls her own childhood by painting her grandparents' home. The table is set with a white cloth, candlesticks, and an enormous vase of flowers. A platter of fruit, the traditional loaf of challah bread, and a honey cake are also set out, suggesting that the meal has already been eaten. It is interesting to note that while the cake is shown whole, there are nevertheless slices of it on the small dessert plates. "Time is compressed in my work," explains Malcah. "I paint several aspects of the event at once." And indeed, her grandparents are dressed in their Sabbath best. But these seeming contradictions are unified by the compelling naive vision that sees time as a simultaneous series of unfoldings rather than a strict, linear progression of events.

Opposite: **FULL TABLE**

Benshen Licht (page 36) is another scene drawn from memory. It shows the moment on Shabbat, eighteen minutes before sunset, when the Sabbath candles are lit. These candles signify harmony in the home and joy in the Sabbath that is about to begin. Traditionally, the woman of the house lights them, emphasizing her crucial role as the monitor and facilitator of the ensuing rituals. Here, the artist's grandmother draws her hands around the candles in a movement symbolizing the six days of creation that led to the seventh, the day of rest. The artist, portrayed as a child, looks on. "When I first began to paint, one of the earliest images that came to me was that of my grandmother lighting the candles," recalls Malcah.

The actual day of the Sabbath is devoted to the study of the Torah. *Sabbath Service* shows the men in a synagogue as they held the Torah. The women are seated separately in the galleries above, as is traditional in Orthodox synagogues. A man at the right holds a Torah scroll, which a congregant touches with the edge of his *tallit*. Typically, a man touches the Torah with his *tallit*, then kisses his *tallit*, a gesture of love and respect for the word of God. "When I first saw this happen, I was stunned by the beauty and tenderness of it," Zeldis says. She secretly wished that she, too, could participate in this marvelous ritual.

After the Sabbath ends, forty-two minutes after sunset on Saturday, the *Havdalah* ceremony, which symbolizes the separation between the Sabbath and the week to come, begins. Essential to the ritual are a candle, a full cup of wine, and a small box containing fragrant spices. All the lights, with the exception of this special candle, are extinguished.

After the candle—which signifies the divine in man—is lit, the wine is blessed, but not drunk. Then the fragrant spices are blessed and passed around for everyone to inhale, for it was believed that the fragrance of these spices helped to dispel any sadness about the end of Shabbat. The candle is blessed, and the person reciting the *Havdalah* either drinks all the wine or else passes it around. A few drops are saved and poured into a dish, where they are used to extinguish the candle.

In *Havdalah* (page 37), the man in the lower left is shown reaching out for the spice box. Fruit, flowers, and wine adorn the table. Outside, night has fallen and the sky is a deep, dreamy blue. The rippling white curtains suggest the sanctity of Shabbat, and the view out the right-hand window—a narrow walk leading up to a small red house, and a birdbath surrounded by roses—is an evocation of Zeldis's childhood house in Detroit. For Malcah and many others, "the meaning of Shabbat resides in the home."

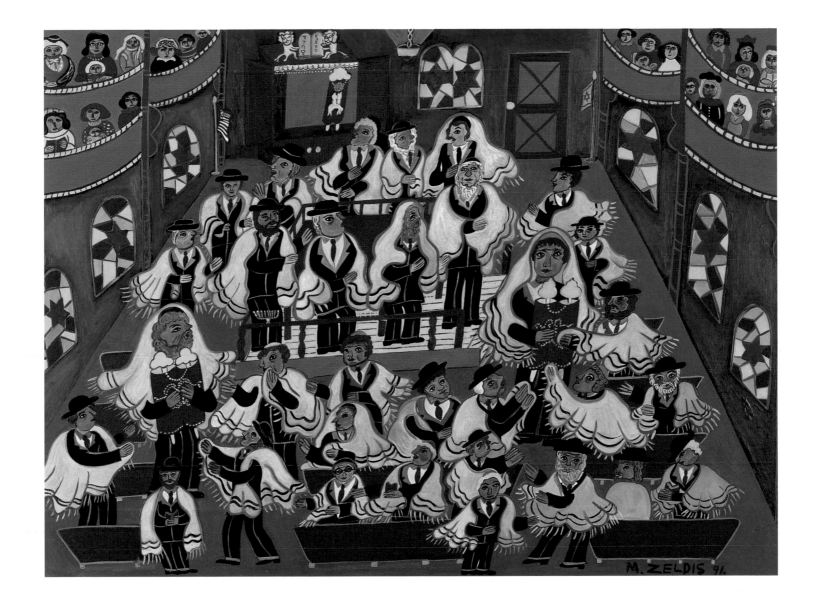

SABBATH SERVICE

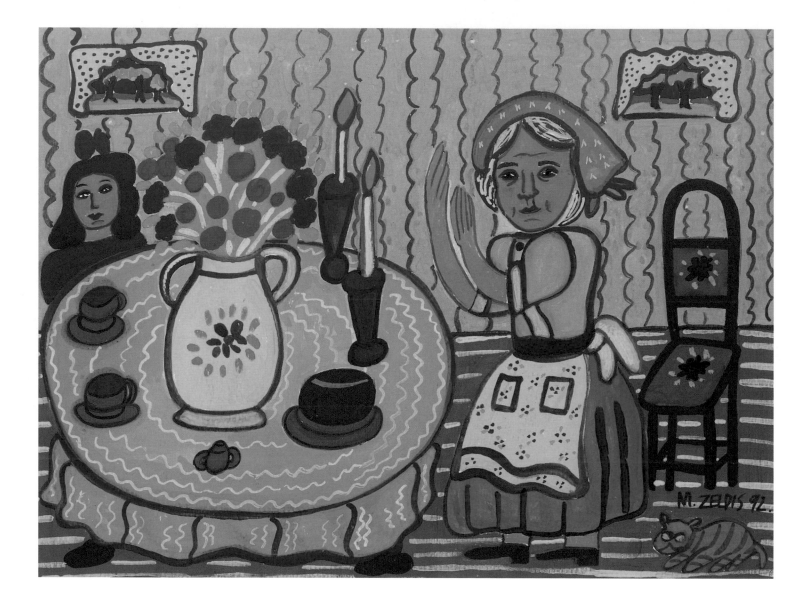

BENSHEN LICHT

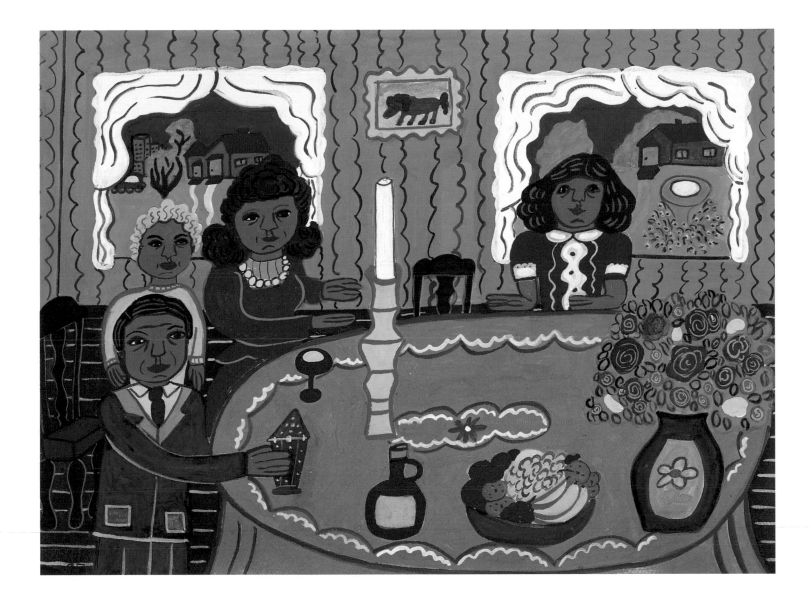

Above: **HAVDALAH**

Overleaf: detail from **SABBATH SERVICE**

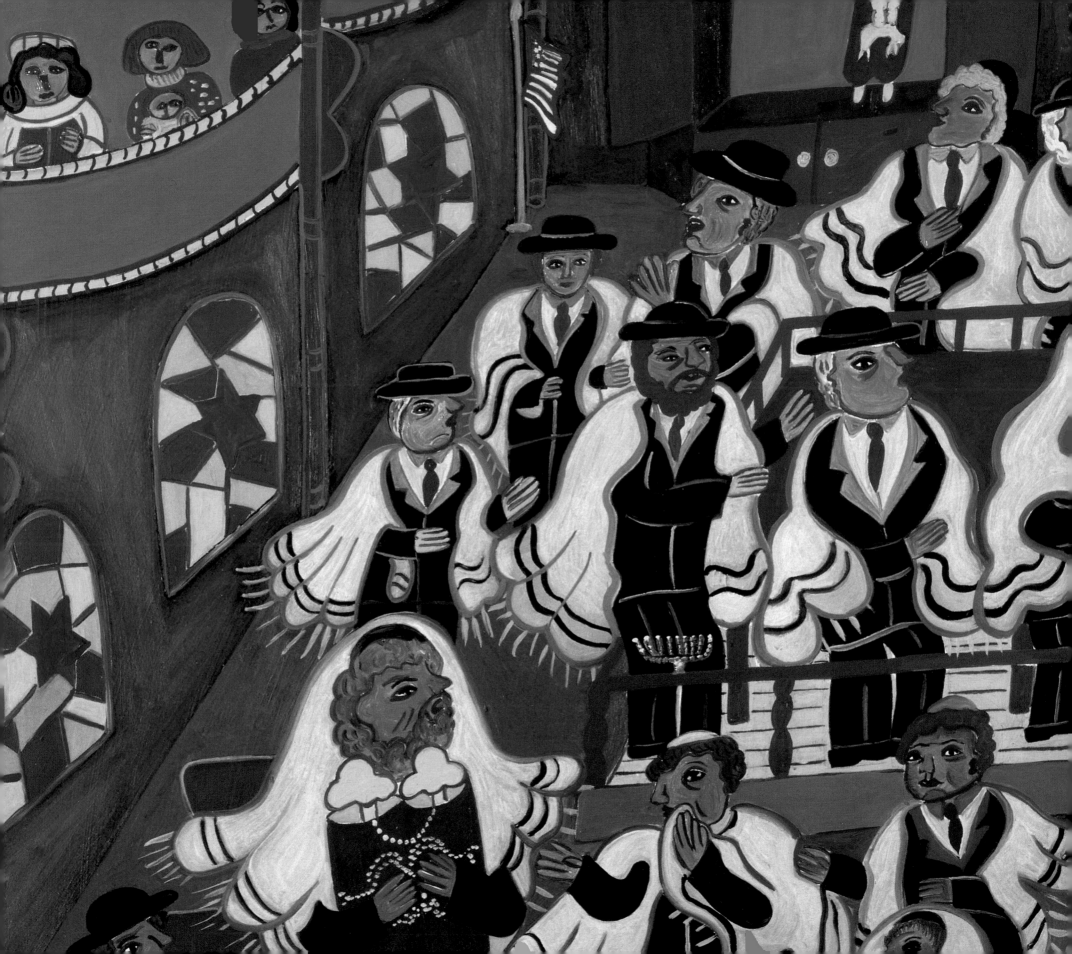

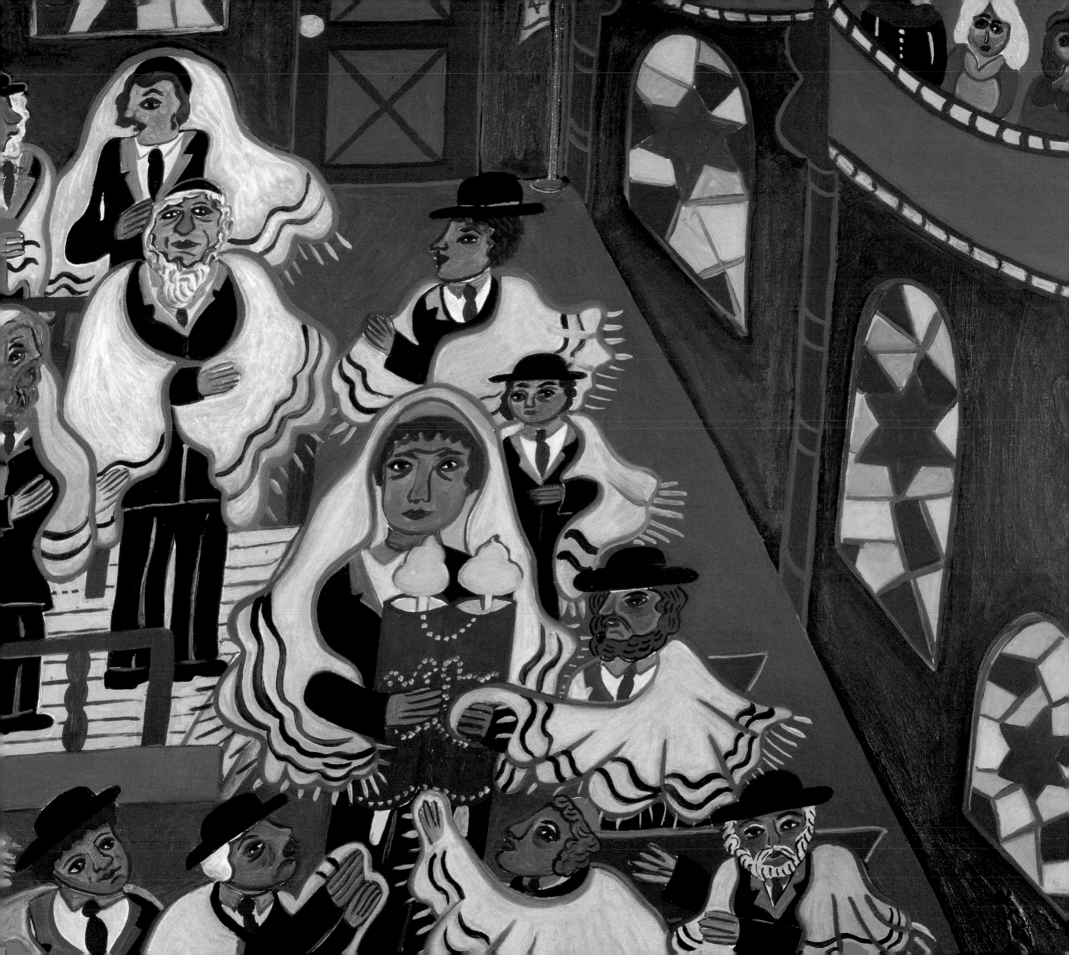

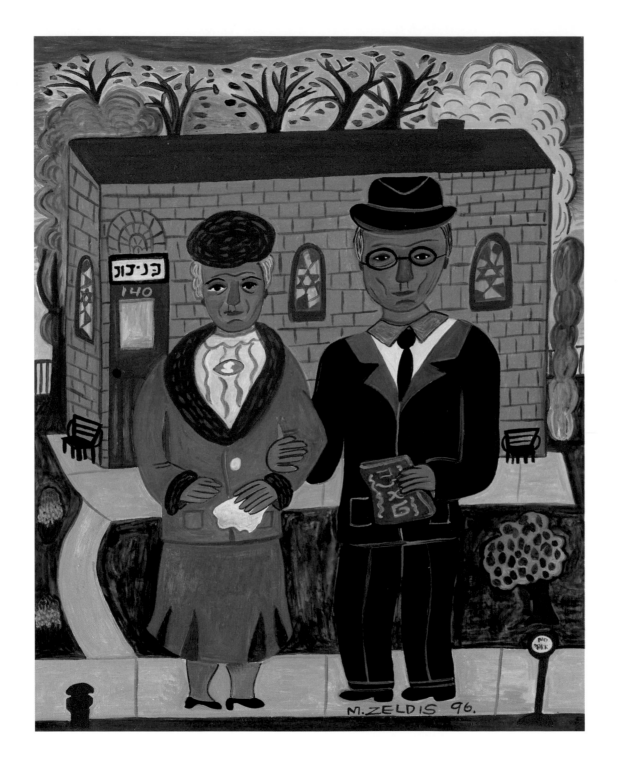

ROSH HASHANAH:
USHERING IN THE NEW YEAR

Rosh Hashanah is a day of judgment and a day of joy. For the Jewish people, the holiday is a time to celebrate the miraculous birth of the world and to reaffirm its faith in God. Rosh Hashanah falls on the first day of the Jewish month of Tishri. The Bible states that this day is to be set aside as a holiday, but it is not specified as Rosh Hashanah. Today, the ancient festival has been split up into three separate holidays: Rosh Hashanah, Yom Kippur, and Sukkot.

Preparations for Rosh Hashanah begin in the month of Elul, which precedes Tishri. The most compelling symbol of this time is the blowing of the ceremonial ram's horn known as the shofar. The shofar's blast functions as a kind of moral alarm, prodding people to begin the self-examination that is essential preparation for the holy days to come. It also prefigures the shofar blowing that is integral to the Rosh Hashanah service.

On the eve of Rosh Hashanah, Jews join together for a celebratory meal to welcome the new year. Rosh Hashanah has serious spiritual meaning, and it is also a holiday whose rituals are filled with optimism and hope. As if to make concrete the wish that the coming year will be a sweet and joyous one, it has become customary in many countries to begin the Rosh Hashanah meal by dipping a piece of bread or a slice of apple into honey, while reciting a traditional prayer: "May it be Thy will, O Lord, our God and God of our Fathers, to renew us into a good and sweet year." Sour foods are avoided at the Rosh Hashanah feast.

The focus of Rosh Hashanah observance is in the synagogue, rather than in the home. Services are long and complex, interweaving the themes of God as king and the birthday of the world. *My Grandparents* shows Zeldis's grandparents dressed and ready for services at the synagogue. The grandfather wears his good hat and coat. The grandmother is dressed in a fur-trimmed suit and matching hat.

Opposite: **MY GRANDPARENTS**

41

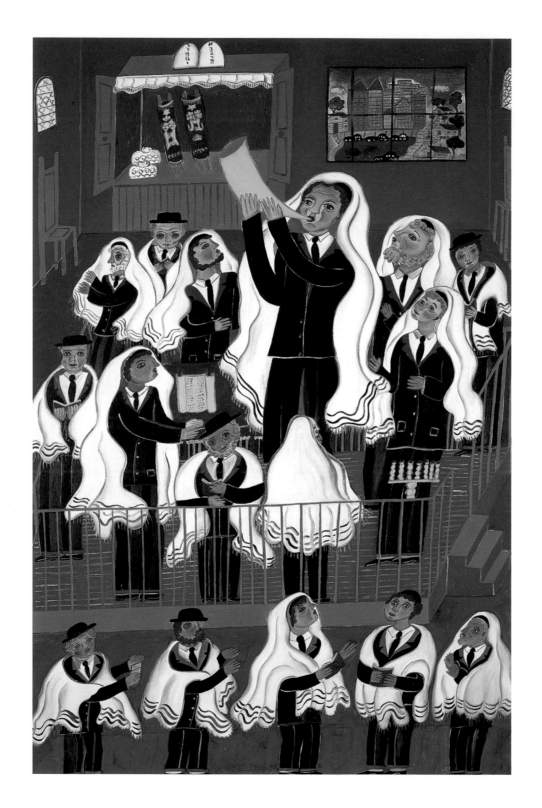

The couple appear somber and stylized in their posture and attitude, as if presenting themselves for a camera. The painting is filled with witty references to their emphatic duality: a pair of trees on either side of the *shul*; the two blue windows that pierce the *shul*'s facade; the black benches and even the street fixtures—a red fire hydrant on the left balanced by a round, red sign on the right.

Blowing the Shofar takes us inside the neighborhood temple frequented by the artist's grandparents; in fact, her grandfather can be seen, second from the left in the top row of men, wearing a black hat. The synagogue is small and relatively unadorned, with plain wood and simple windows. Central to the image—and to the holiday it depicts—is the ritual blowing of the shofar. Shofar blowing requires talent and skill; people are specially trained for this exacting task. The order of the notes is strictly prescribed and allows for no deviation from its time-honored form. At several points during the service, a member of the congregation calls out the Hebrew names of the notes to be sounded. There are three basic sounds: *teki'ah*, a short blast; *shevarim*, three shorter blasts; and *teru'ah*, nine very short blasts.

In the afternoon, it is customary to perform a ritual called *Tashlich*, or casting. Jews have traditionally gathered at the shore or bank of a river, ocean, or any other body of free-flowing water. There, they empty their pockets—filled with bread crumbs for this purpose—into the water. This act is thought to have derived from the biblical quotation that exhorts: "And thou will cast all their sins into the depths of the sea" (Mic. 7:19). Symbolically, it is a way of casting off the sins from the previous year—which are then carried away by the running water—and beginning the new year afresh.

Opposite: **BLOWING THE SHOFAR**

YOM KIPPUR: REPENTANCE AND FORGIVENESS

Yom Kippur is a day of negation. Instead of definitive action, it is the restriction upon action that marks the day: Jews may not eat or drink; they may not wash or anoint themselves; they may not wear leather shoes, and they must not make love. All these activities were seen as pleasurable, and for this one day, devout Jews were called upon to abstain from pleasure. (Those who are very old, very young, sick, or weak, however, are exempt from fasting.) Yom Kippur is more like Shabbat than like a festival, with regard to work and the prohibitions placed upon it; carrying or using fire, and cooking are not permitted. In fact, the day is known as *Shabbat shabbaton*—a Sabbath of complete rest.

The ten days between Rosh Hashanah and Yom Kippur are called the "Days of Awe" and are set aside for the cleansing of the soul. This is a time of intense introspection and self-scrutiny, during which forgiveness for one's sins is fervently sought. At the end of the ten days, Yom Kippur, the official day of atonement, begins.

The evening before, Jews eat a large and nourishing meal in preparation for the rigorous fast that is to follow. Very observant Jews have traditionally practiced a ritual known as *kappores*, as seen in the painting of the same name. During the ritual, a live chicken is swung around the head, and the person utters these words: "This is my change, this is my compensation, this is my redemption. This cock is going to be killed, and I shall enter upon a long, happy, and peaceful life." When the rite is completed, the chicken is killed and given to the poor. Malcah has powerful memories of her grandfather performing this ceremony. Years later, her father gave her some nineteenth-century Jewish postcards, one of which depicted *kappores* with two men and two chickens; this, along with her early recollection, provided the inspiration for the painting. The three male figures are grouped together, on one side of table, while the one female—in this case, the

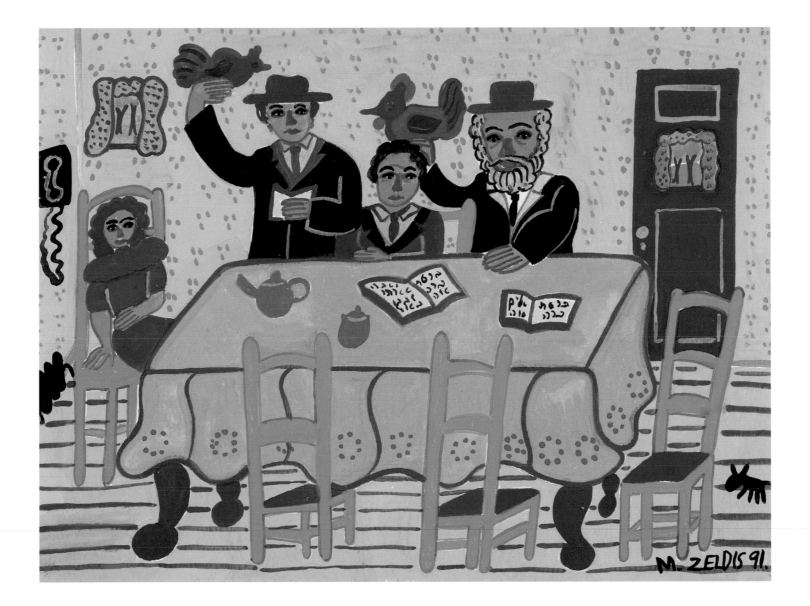

KAPPORES

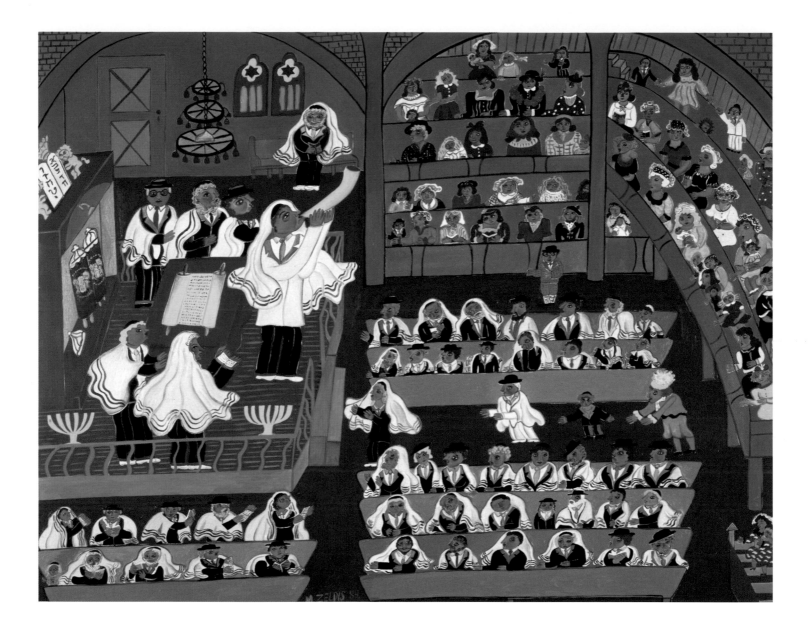

artist as a child—is seated by herself at the table's end. This is a motif that recurs frequently in her work, showing the artist as somewhat isolated from the events around her, yet also as their witness: the child who would grow up to record and commemorate the rituals and observances she saw, but in which she did not always fully participate.

Share Tzedek depicts the Yom Kippur service held at Share Tzedek, "the fancy *shul* in Detroit," to which the parents of a close childhood friend belonged. Many of the congregants are noticeably well dressed; the balcony shows several women wearing stylish—by the standards of the 1930s and 1940s—suits and hats with veils. There are also many figures dressed in white, which symbolizes purity, and which is customary garb on Yom Kippur. At the left, we see a man blowing the shofar; its final, plaintive call represents the sealing of the heavenly gates until the following year.

But the *shul* is not only a place of worship and exalted religious feeling; it is also a meeting place for Jews where life in all its commonplace wonder unfolds, as is suggested by the small child running down the aisle. A woman trots after him, willing to allow him his freedom while still keeping her eye on him. That children run free and adults do their best to protect them is an aspect of everyday life that infiltrates even this holy occasion.

Overleaf: detail from **SHARE TZEDEK**

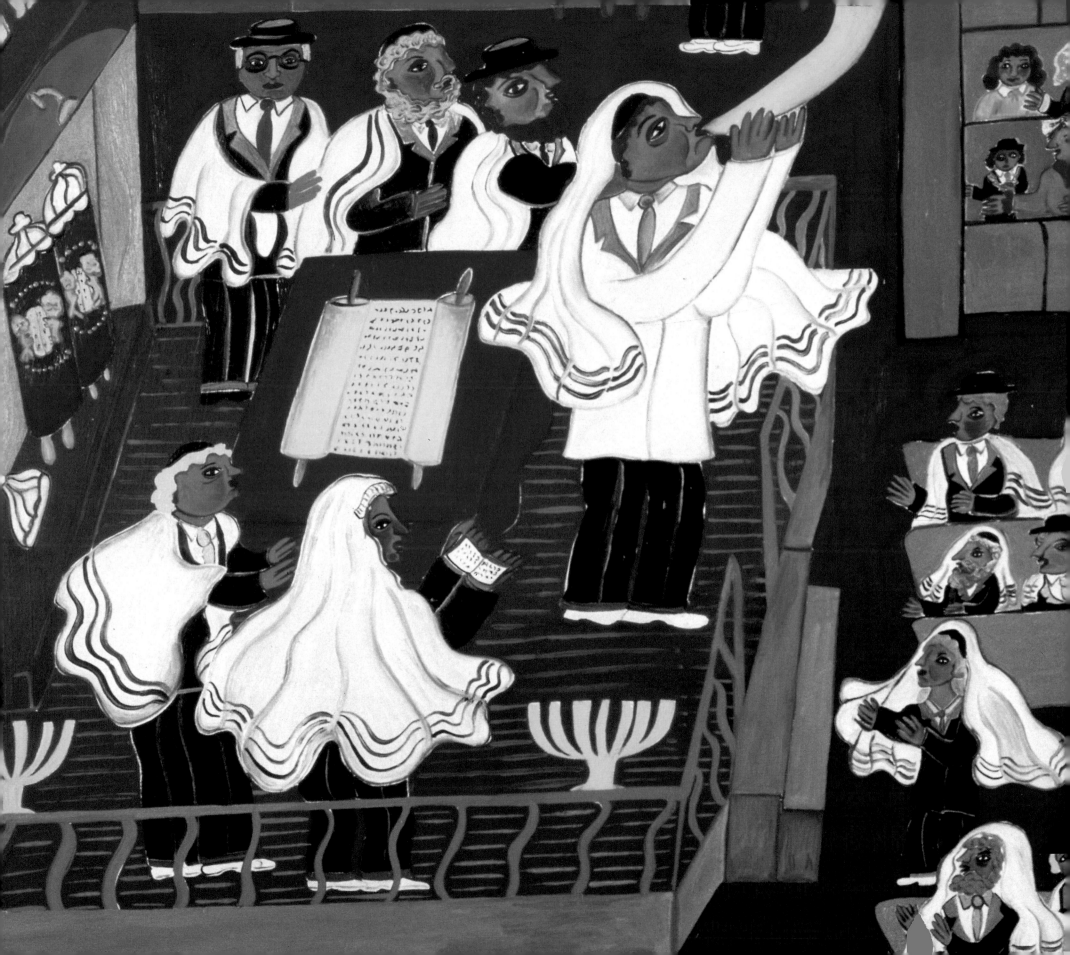

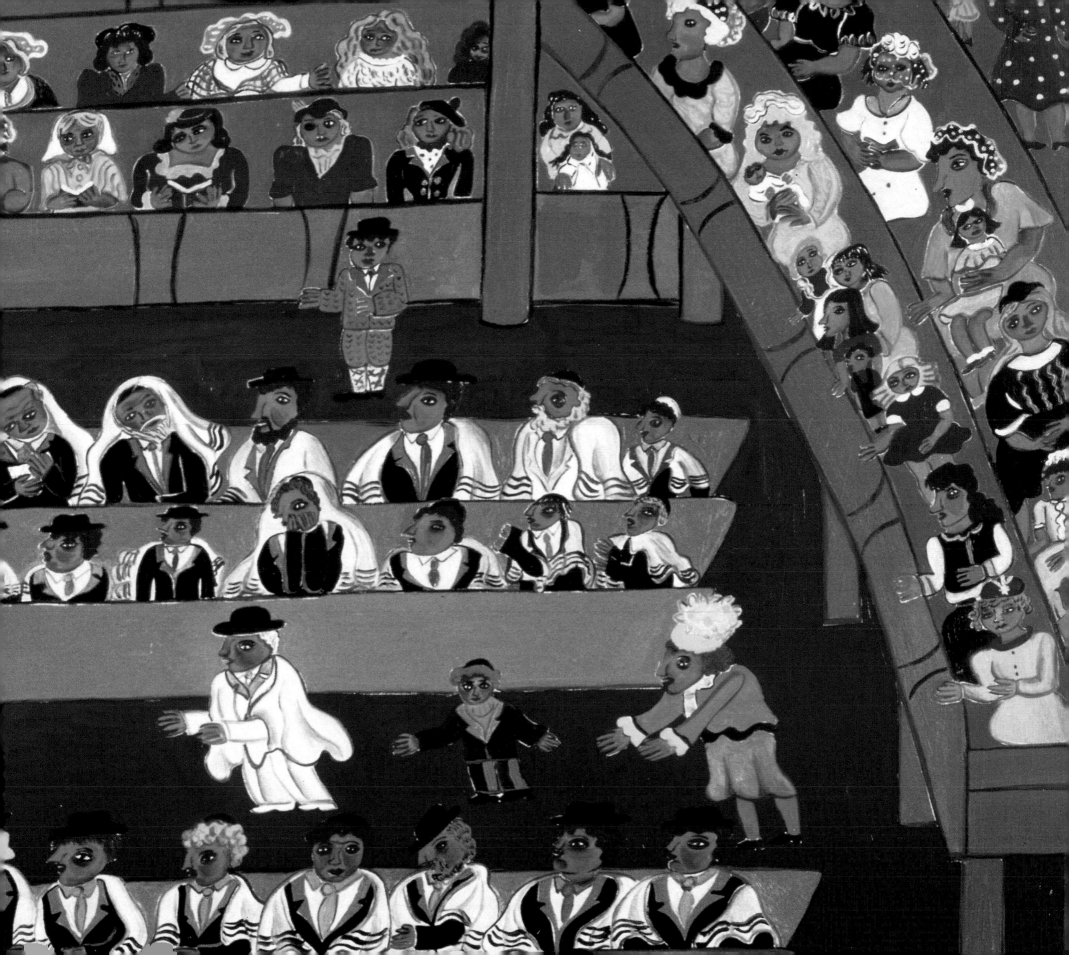

SUKKOT AND SIMCHAT TORAH:
CELEBRATING THE HARVEST

ccurring just five days after Yom Kippur, Sukkot—also known as Feast of the Booths—is the longest and most joyful festival in the Jewish holiday cycle. Sukkot is believed to be agricultural in its origins. Its alternate Hebrew name, *Chag Ha-Asif*, means "Festival of the Ingathering," and certainly, the harvest and nature's bounty are integral to the holiday.

The sukkah, or tabernacle, is the central symbol of Sukkot. It is a reminder of the portable tabernacles, or booths, in which the people of Israel lived during their years of wandering in the desert, following the exodus from Egypt. The sukkah also refers to the most ancient origins of the holiday, which are thought to have been derived from nature festivals. Jews of the ancient world traveled in caravans to sanctuaries where they could worship God, each bringing something—a calf, a goat, or a vessel of wine—to sacrifice. People gathered in large crowds and set up tents and booths for several days and nights of singing, dancing, and drinking—all of which must have been a welcome respite from the long, lonely months during which they lived on isolated farms and grazing meadows.

Traditionally, the building of a sukkah is a family affair that begins just after the conclusion of Yom Kippur. There are specific rules about where and how the sukkah is to be constructed. The roof, which must be attached only after the walls are complete, must be made of thatch—leaves or branches—which allows the stars to shine in at night and the rain to fall through; the openings may not exceed 11 inches (27.9cm) in width or length. The walls may be wood, metal, canvas stone, or brick. The minimum height for a sukkah is 35 inches (88.9cm); the maximum, 35 feet, 3 inches (10.7m). When completed, the sukkah is decorated with flowers, fruits, nuts, gourds, and other symbols of the harvest. In Middle Eastern countries, the walls of the sukkah are hung with rugs; in Eastern Europe, a tradition grew of creating intricate paper cutouts and ornaments, which were suspended from the roof.

Opposite: **IN THE SUKKAH**

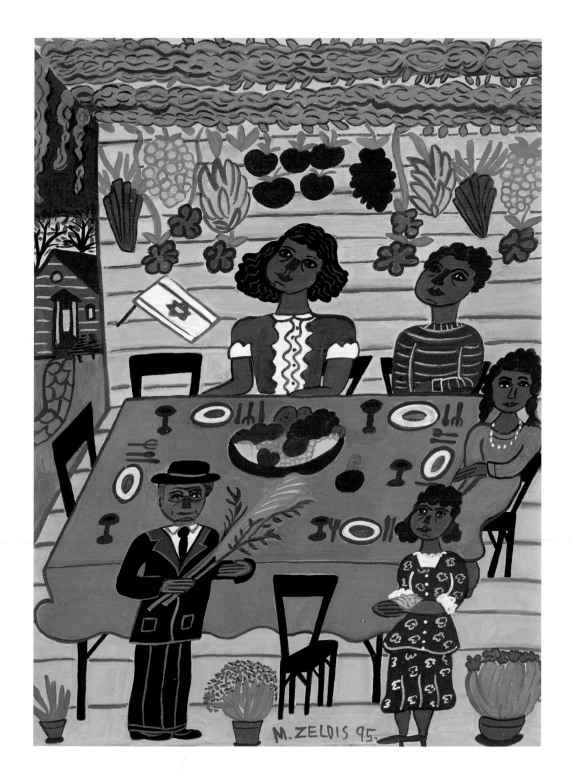

The sukkah is meant to be a temporary dwelling—to emphasize the fragility of life—but it must be sturdy enough to endure for seven days. Although some very observant Jews actually sleep in the sukkah, it is not intended as a place of suffering; therefore, most people simply eat and socialize in their constructed dwellings, and take to their beds indoors.

In the Sukkah (page 51) depicts a family about to enjoy their meal in the wondrously decorated structure. The artist, shown as a young girl, gazes up at the abundance of fruits, vegetables, and flowers that hang overhead. "There was always something magical about being inside a sukkah," she recalls. At the left, an Israeli flag forms part of the decorative scheme, and beyond that, the signature house, with its stone pathway, serves as a reference to the artist's childhood home.

The man and woman at the bottom of the painting hold what have come to be called the Four Species. According to the Book of Leviticus (23:40), "You shall take on the first day [of Sukkot] the fruit of goodly trees, branches of palm trees, and boughs of leafy trees, and willows of the brook; and you shall rejoice before the Lord your God seven days." This passage gave rise to the ceremonies connected with four plants— citron (etrog), palm branch (lulav), myrtle (hadas), and willow (aravah)—which are brought into the synagogue and waved on several occasions during the service. Here, we see the sukkah and the Four Species, which would have been used in the synagogue and not in this context; however, in the artist's pictorial imagination, informed by her childhood memories, they are together.

Sukkot culminates with the festival of Simchat Torah, "Rejoicing in the Law." This day celebrates the completion of the yearly cycle of Torah readings with the beginning of a new cycle. In the late Middle Ages, Ashkenazic Jews began the custom of taking all the Torah scrolls from the ark and marching with them around the synagogue, a practice that continues today. Children are especially welcome to join the procession, and are given Simchat Torah flags to wave. Often, the Torah scrolls were decorated with special ornaments—crowns and covers were common—and in some communities in the Middle East, women used their own jewels to adorn the Torah.

Opposite: SIMCHAT TORAH

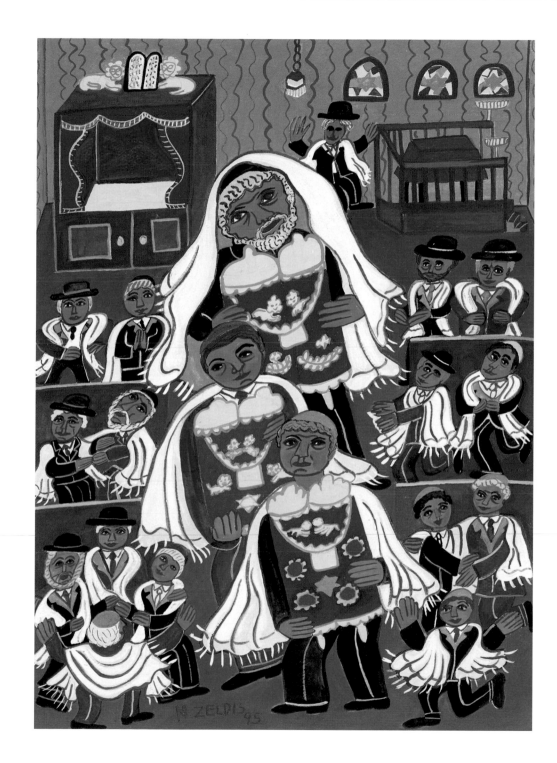

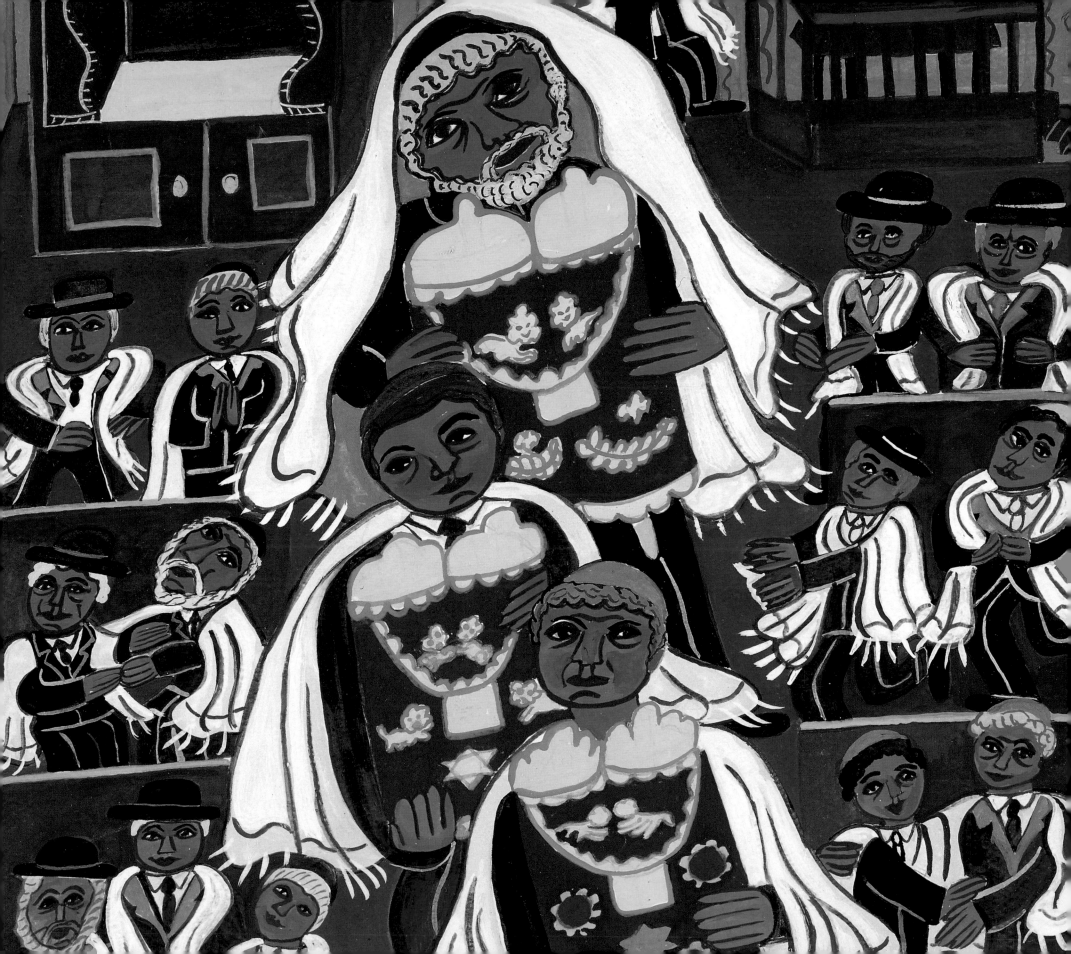

In *Simchat Torah*, we are once again in the *shul* where the artist's grandparents worshiped. The decorated Torah scrolls are being paraded around the synagogue while clusters of men at the lower left and right are shown in a joyous dance. "When I was living in Brooklyn, in Crown Heights, I saw the Simchat Torah celebration taking place in the streets of the neighborhood," says Malcah. "The thing that touched me so much was the way the Torah was revered—like a queen or a king—and how much joy my people took in it. The artist in me loved the idea of adorning the Torah—secretly, I always longed to make a Torah cover of my own; my paintings allow me to do that.

I took delight in the rich coloration of the Torah mantle and it inspired me to paint a Torah of my own—thus adorning it. My spiritual life has always been enhanced by my art. In my work, I restore to myself my childhood and my sense of the sacred in life.

I also knew that lives of many of the worshipers had not been easy, yet they were still able to rejoice. I found it both astounding and uplifting that they could find such spiritual sustenance in their faith."

Opposite: detail from **SIMCHAT TORAH**

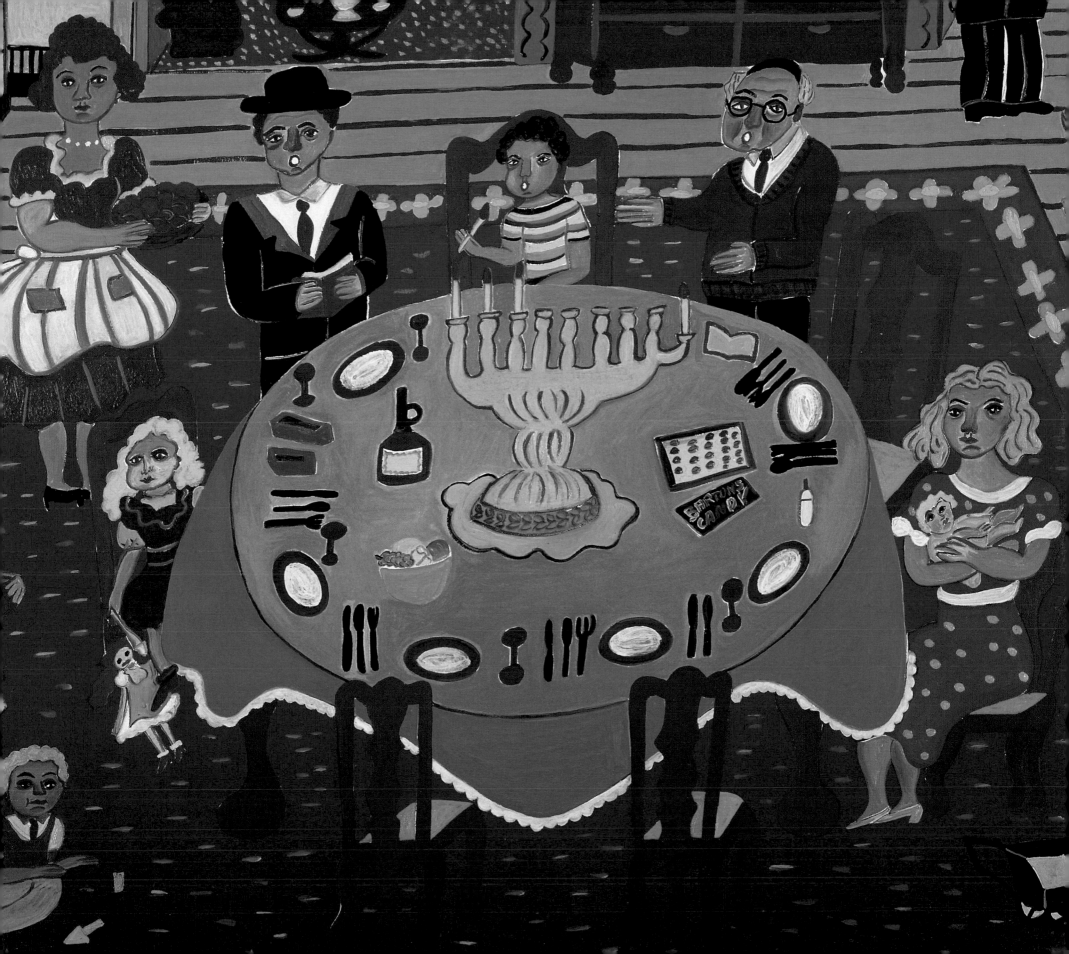

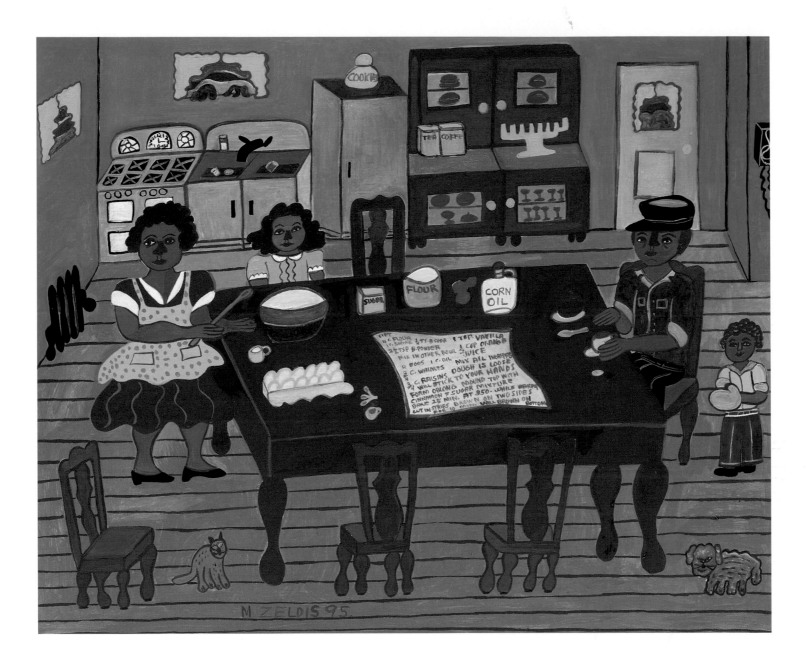

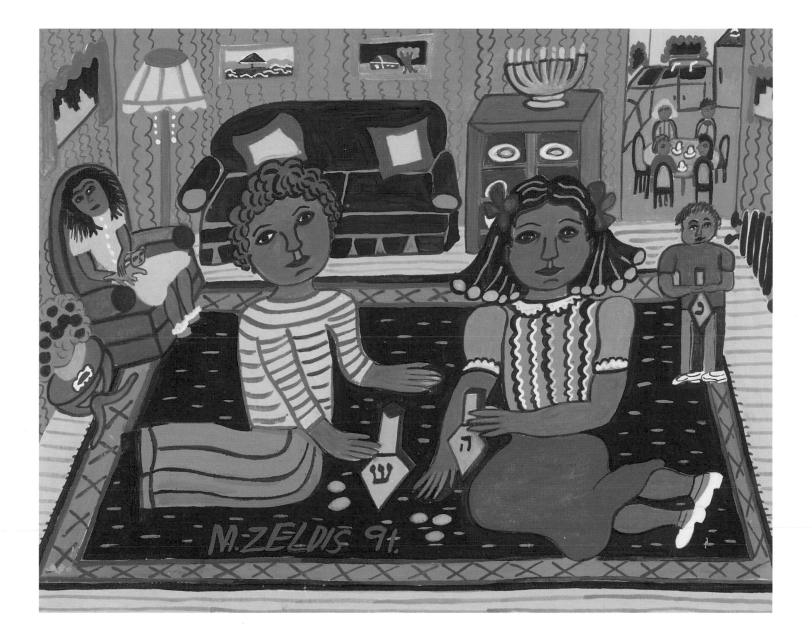

PLAYING DREIDEL

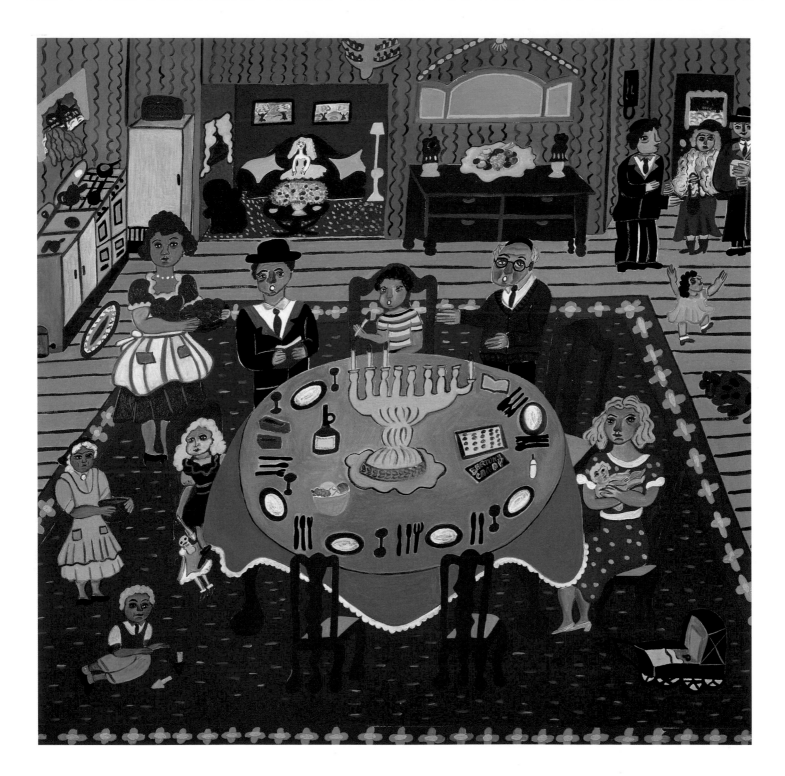

The best-known of the customs associated with Chanukah is the lighting of the menorah, one candle for each of the eight nights, to symbolize the eight-day miracle. In *Chanukah*, we are once again back in the land of memory, attending a Chanukah party in Zeldis's childhood home. Central to both the party and image is the menorah, placed prominently on the table. A small boy holds a candle, in preparation for the lighting. Three of the figures are seen with open mouths; no doubt, they are singing a traditional Chanukah song. At the upper right, some guests are ushered in; at the lower left, a small boy plays with a pair of dreidels.

Indeed, Chanukah has long held a special significance for children, who are given *gelt* (money), small gifts, and treats of chocolate, honey, fruit, and almonds. The dreidel game, a game of chance played with a spinning top, is enjoyed by Jewish children to this day. Derived from the German word *drehen*, "to spin," dreidels were commonly used by Ashkenazic Jews at Chanukah. The Hebrew letters *nun*, *gimel*, *he*, and *shin* are marked on the sides of each dreidel; these letters form an anagram for the words *nes gadol hayah sham*, which mean "A great miracle happened there." The letters also indicate the outcome of every spin: *nun* means *nichts*, or nothing; *gimel* means *ganz*, or everything; *he* is *halb*, or half; and *shin* means *shtell*, or pay, requiring that the spinner pay into the pot.

Playing Dreidel (page 59) depicts two children seated on the floor, each with his own dreidel. A third boy, also holding a dreidel, is seen farther back. On a china closet behind the children sits a menorah, fully lit. Each child holds a dreidel, and delights in the hypnotic, whirling motion of the spinning top.

Opposite: **CHANUKAH**

PURIM: THE FEAST OF LOTS

Purim, which falls on the fourteenth day of the Jewish month Adar, is a story with a bona fide Jewish heroine. The holiday celebrates how Queen Esther and her cousin Mordecai saved the Jews of Persia from a plot to exterminate them. The prime minister, Haman, who hated Mordecai for his refusal to bow down to him, had cast *purim* (the ancient word for "lots") to determine the day that the Jews would be slaughtered. But Queen Esther, whose husband, King Ahasuerus, hadn't known she was Jewish, pleaded for her people to be spared. Moved by her eloquence, her sincerity, and her bravery, the king agreed. The Jews were saved, and the evil Haman was hanged on the very gallows that he had constructed for Mordecai.

While Purim has a clear biblical origin—the story is recounted in the Book of Esther, which is read twice during the holiday—it also falls close to and shares traits with other holidays, such as the Christian Carnivale and the pagan arrival of spring. During Purim, it is traditional for adults and children to dress up as Esther, Ahasuerus, Haman, and Mordecai, and to put on plays, known as *Purimshpiel*, enacting the story. Drinking and merrymaking are expected—and encouraged—as the holiday has become a symbol for the salvation of the Jews, who survive despite the many attempts to exterminate them. Among the traditional foods are hamantaschen ("Haman's pockets"), which are three-cornered cakes filled with poppy seeds.

Dressed for Purim shows the artist and her brother dressed in their holiday costumes. He is dressed as the Persian king, with a turban, sword, and cape; in his hand is the *gregger*, the traditional noisemaker used to drown out Haman's name whenever it occurred in the reading of the Book of Esther during the temple services. The artist is shown dressed as Queen Esther, in a crown, necklace, and earrings, and wearing a crocheted shawl. A tiny mask dangles from her fingers. Although Malcah refers back to her childhood for the image of the children, the setting in which they are shown is not her Detroit home, but rather the Brooklyn apartment where she lived as an adult with her own two children. Once again, her work joins together disparate elements—here, past and present—to create a unified pictorial whole.

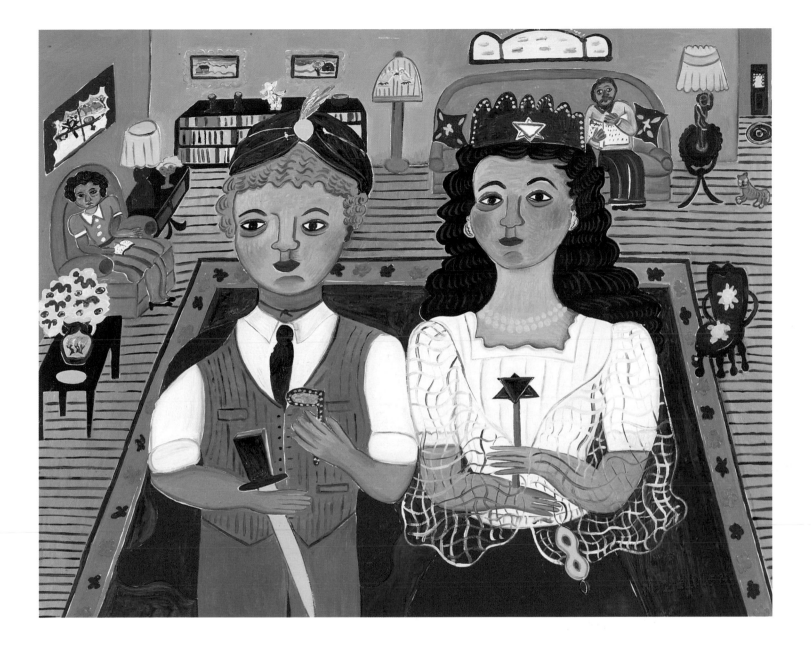

DRESSED FOR PURIM

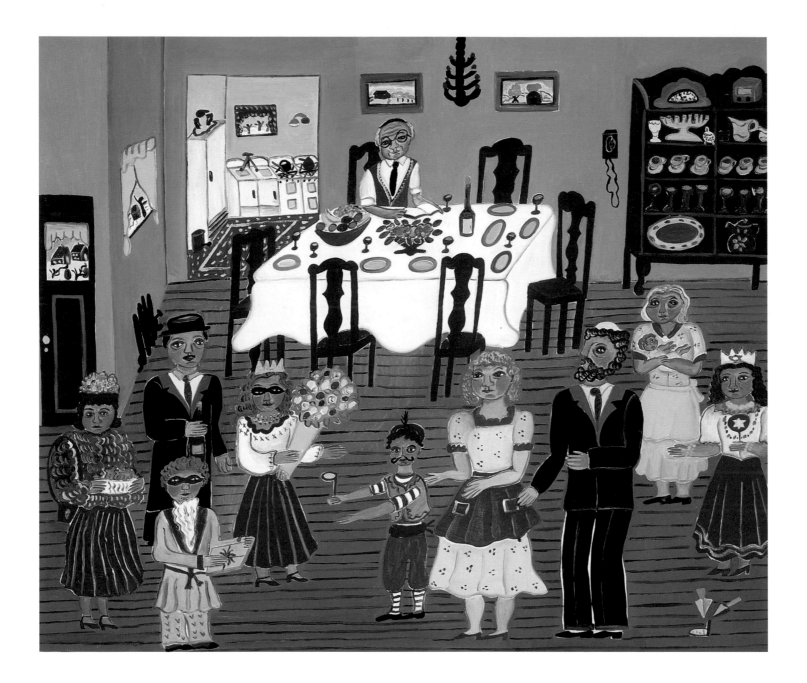

SHALACHMONES

Shalachmones takes us back to that Detroit world, where the Zeldis family is shown receiving visitors who have brought the traditional gifts of prepared foods to their friends. "I remember reading about the custom of *shalachmones* or *mishloach manot* in a story by Isaac Bashevis Singer, and I wanted to paint my family in this way." The guests—two of whom are masked children—bring wine and baked goods to the family, who reach out their arms to accept the offerings. The artist and her brother, costumed as they were in *Dressed for Purim*, are part of the group. In the background is the artist's grandfather, engaged in prayer or study, as his open book suggests.

"I think I have painted Purim so many times because my name, Malcah, means queen, and I admired the courageous, wonderful queen who risked her life to save her people." says Zeldis. "When I went to Israel in the late 1940s, at the age of seventeen, I felt that I, too, was a kind of Esther, embarked on a mission to help my people who were in need."

PESACH: LONG LIVE FREEDOM

Pesach, the Passover holiday, begins on the fifteenth night of the Jewish month of Nissan. During the festival meal, the youngest child at the table asks, "Why is this night different from all others?" The answer lies in the story of an ancient exodus for the Jewish people. Thousands of years ago, when the Jews were slaves in Egypt, a Jew named Moses asked the pharaoh for their freedom. When the pharaoh scoffed at his plea, God sent a series of horrific plagues to torment the Egyptians. None but the last—the slaying of the firstborn—persuaded the pharaoh to free the Jews, who marked their doors with lamb's blood so that the Angel of Death would pass over their houses; hence, the name "Passover." The Jews fled quickly, fearing that the pharaoh would change his mind. They didn't even have time to wait for their bread to rise, which they had baked in preparation for the journey. To this day, Jews eat matzo, or unleavened bread, to commemorate the flight of their ancestors. Pharaoh did, in fact, change his mind, and his army pursued them as they fled toward the sea. There, Moses performed the miracle of parting its waters so that the Jews could safely pass, while Pharaoh's armies, which followed close behind, were drowned when the water rushed back over them.

The celebration of Pesach, a joyous, springtime holiday, is the celebration of freedom. To prepare for it, Jews search the house for leaven of any kind, which is then destroyed. The highlight of the Passover holiday is the seder (Hebrew for "order"), a ritualized meal in which a story from a book called the Haggadah (meaning "telling") is read aloud. In *The Four Questions*, the grandmother tells the assembled group of children the Passover story before the seder begins. In *The Seder Table* (page 68), the table is pictured before the meal: at the right are the Pesach plate, a goblet, and the Haggadah; at the left is a bottle of kosher wine and the pitcher of water used for the ritual cleansing of the hands. Given prominence in the center of the table is the matzo, covered by an embroidered cloth. *Seder Meal* (page 69) is a wonderful companion painting to this image; together they could be called "Before and After." Here, we see the same interior, with the same table that contains many of the same elements. This time, however, the scene is filled with the many

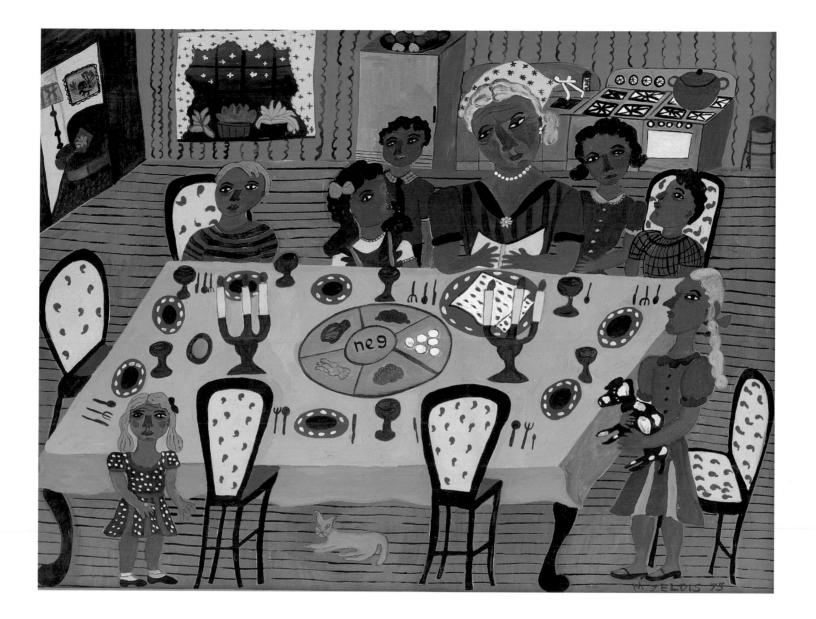

THE FOUR QUESTIONS

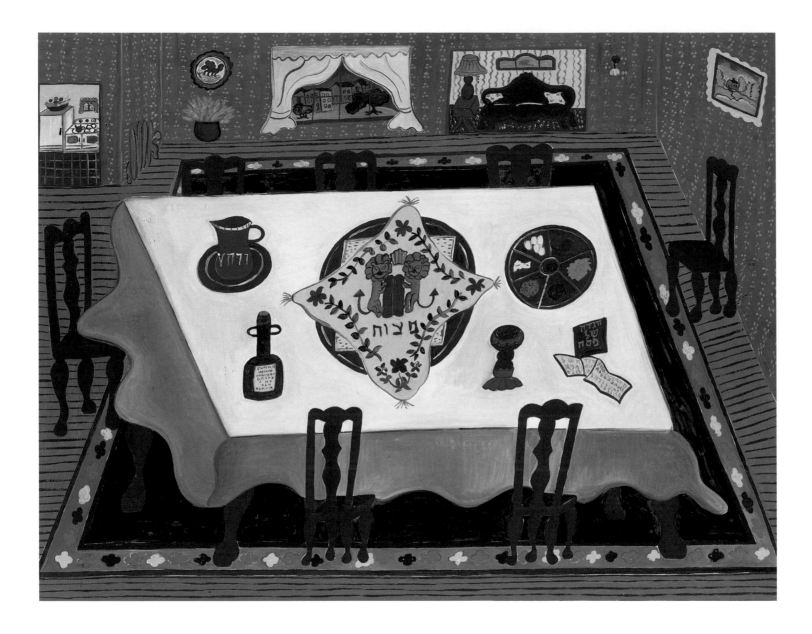

THE SEDER TABLE

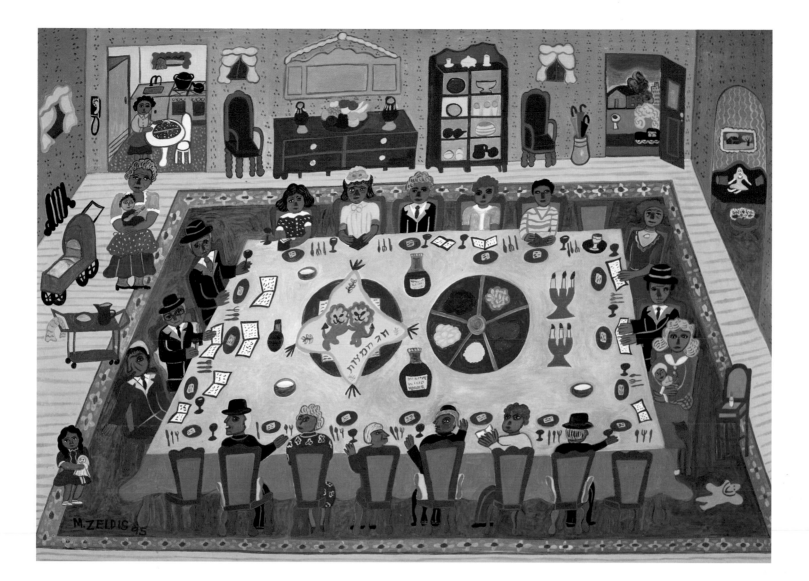

Above: **SEDER MEAL**

Overleaf: detail from **SEDER MEAL**

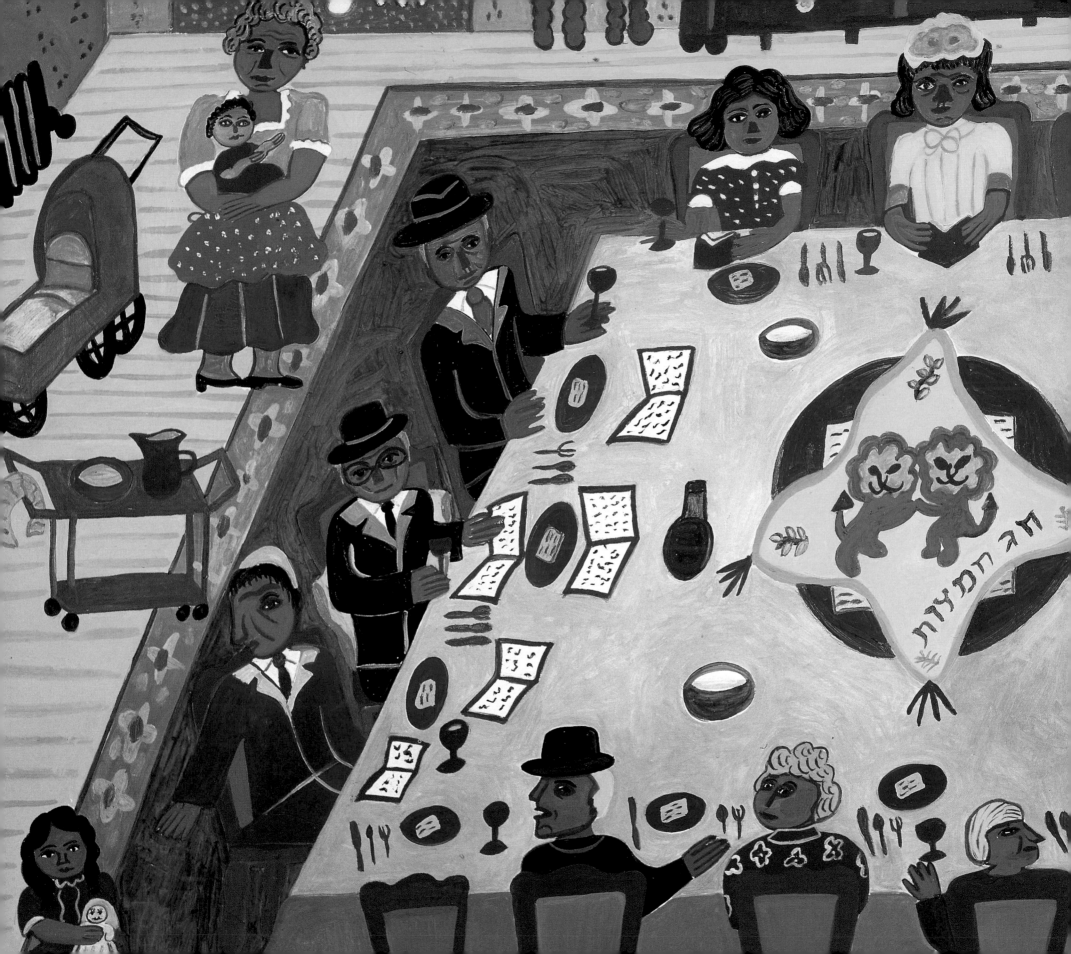

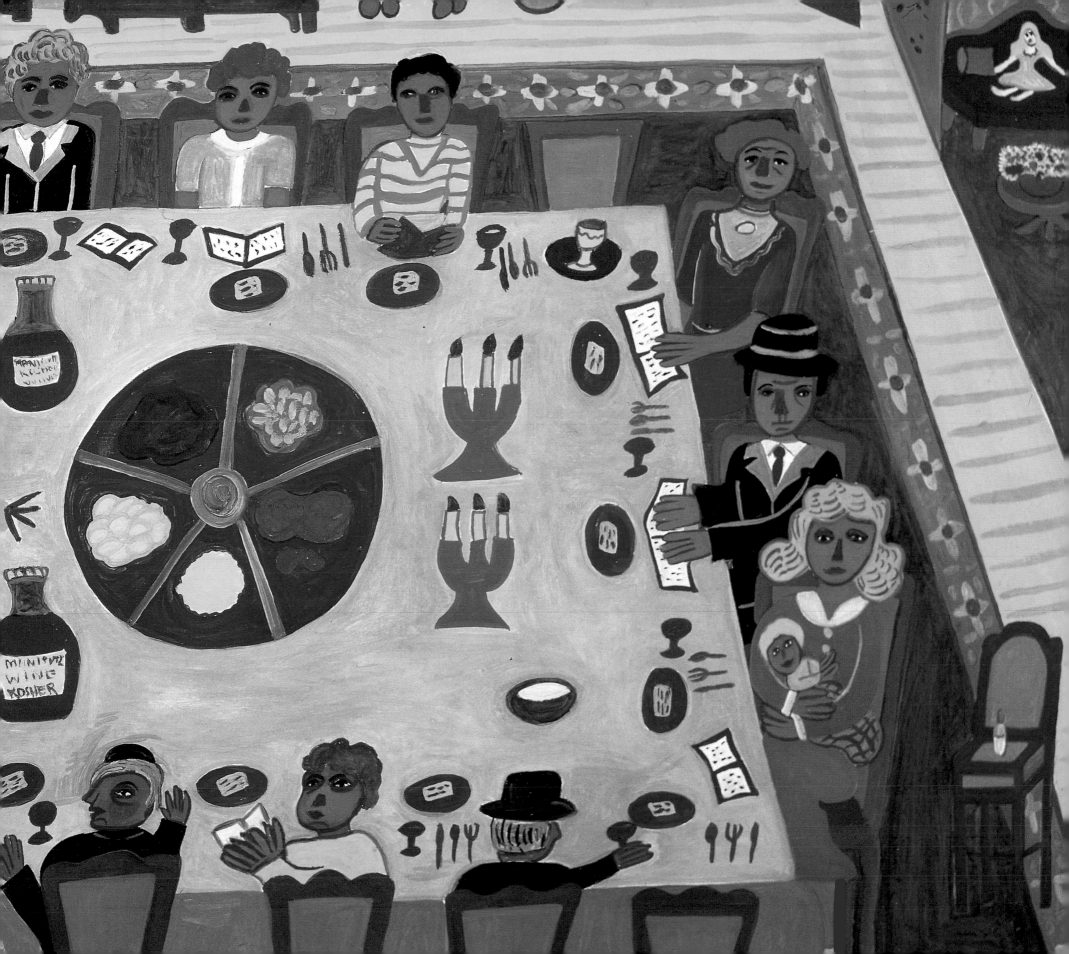

SEARCHING FOR THE AFIKOMEN

lively guests who celebrate the feast. All those at the table join in the prayers, songs, formalized questions, and responses. The food served at the seder consists of things associated with the departure from Egypt, as can be seen from the items on the Pesach plate.

During the ceremony, four cups of wine are to be drunk, commemorating the four verbs used in the act of redemption. Before the seder begins, a special cup of wine is poured for the prophet Elijah, who, it is believed, will usher in messianic deliverance. He is believed to visit every Jewish home on Pesach; after the meal, one of the participants opens the door so that he may come in. Here, the empty chair, the wine glass placed before it, and the open door are all references to his imminent appearance. the six candles on the table are a more recent custom, lit in memory of the six million Jews lost in the Holocaust. At the left, the small girl holding the doll is the artist as a child, seen in what we have come to understand as her characteristic position of onlooker or witness to the events being depicted.

Another Passover custom is seen in *Searching for the Afikomen*. Early in the meal, a piece of the matzo, the *afikomen*, is broken off and hidden by the leader of the seder. Later, all the children at the table are sent to look for it. The one who finds it gets a prize. Once the *afikomen* has been found, it is eaten by all those at the table—the last thing to be consumed at the seder. Here we see a group of children combing the room to hunt for the coveted *afikomen*; from the smile of the child at the top left, we may assume that she is the lucky finder.

"I paint the seder over and over because, as a child, it was my favorite holiday," explains Malcah. "I always put the same people—the members of my family—in my seder pictures, which is a way of drawing them close to me once again."

SHAVUOT: THE FESTIVAL OF WEEKS

havuot, which means "weeks" in Hebrew, is an agricultural holiday held exactly seven weeks after Pesach. The Torah calls it *yom habikkurim*, or "day of the first fruits," because in ancient times, farmers would bring the first of their harvest to Jerusalem as an offering of thanksgiving to God. Shavuot also commemorates the giving of the Ten Commandments at Mount Sinai.

One of the customs associated with the holiday is the eating of a dairy meal. Some scholars have explained this custom by citing the legend about how before receiving the Torah on Shavuot, Jews were not bound by *kashrut* (dietary laws); they ate pork and other nonkosher meats. On Shavuot, they first learned of these restrictions, which rendered all their utensils and dishes nonkosher, and thus not fit for use. Without kosher meat and utensils, they had no choice but to eat dairy foods. Another explanation for this custom is the verse quoted by an ancient farmer at the conclusion of his pilgrimage to Jerusalem: "And He gave us this land, a land flowing with milk and honey."

Shavuot draws upon this latter interpretation for its source. The table is laden for the dairy meal; a large container of milk (its gleaming whiteness echoed by the curtains at the windows) and a jar of honey are sitting prominently on it. The artist's grandparents appear at the bottom of the painting. Malcah recalls that her grandmother baked the challah, and her parents brought the bagels that cover the round blue platter.

"Holidays that emphasized food were important to my parents," remembers Malcah, "perhaps because the memory of having gone hungry was still fresh in their minds. There was always a great to-do made about the shopping for and preparation of the meal, and there was always an abundance of food served— much more than could be eaten."

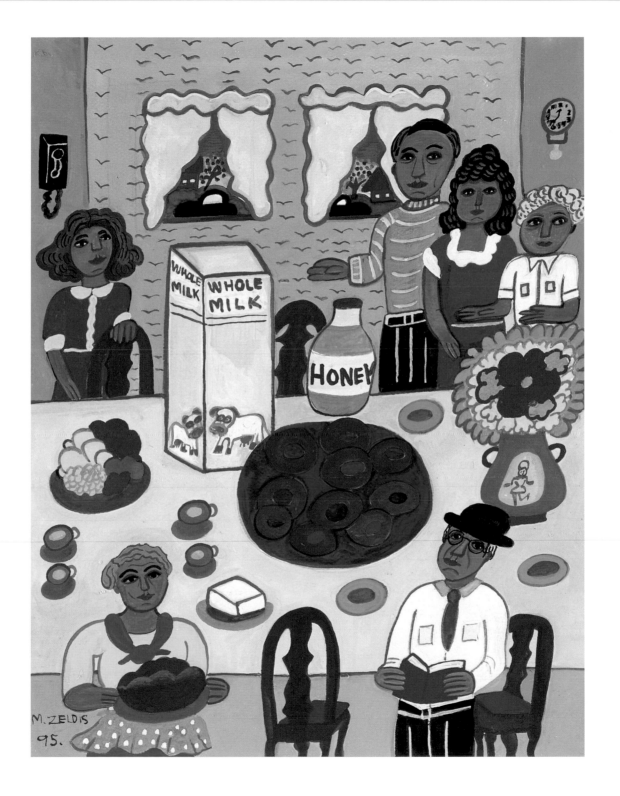

ENTERING INTO THE COVENANT: BRIT MILAH

Many of the rituals surrounding the births of Jewish children are reserved exclusively for males: these include the *brit milah*, or ritual circumcision, through which the newborn enters the fold of Judaism, and the *pidyon haben*, redemption of the firstborn. At a *brit*, a boy is held in the lap of his *sandak* (godfather) while a person called a *mohel* performs the actual circumcision. When the *mohel* is finished, the gathered guests respond, "Just as he entered the covenant, so may he grow up to the study of the Torah, to the nuptial canopy and to good deeds."

Malcah's painting B*rit* M*ilah* depicts a newborn baby held in the arms of the *sandak* while the rabbi holds an open prayer book. The guests partake of the customary wine and sweets that are laid out on a snowy white tablecloth; that cloth is echoed below on the right, where we see the box and bag that hold the ritual circumcision implements.

"The baby's mother and grandmother are shown in through the open door of the bedroom at the left, because often, the mother finds it hard to watch the actual circumcision," explains Malcah. Nevertheless, the happy faces of the guests, the benign look of the rabbi, and the brilliant colors of this painting—which include magenta, turquoise, and red—all contribute to the joyfulness of the scene.

Opposite: **BRIT MILAH**

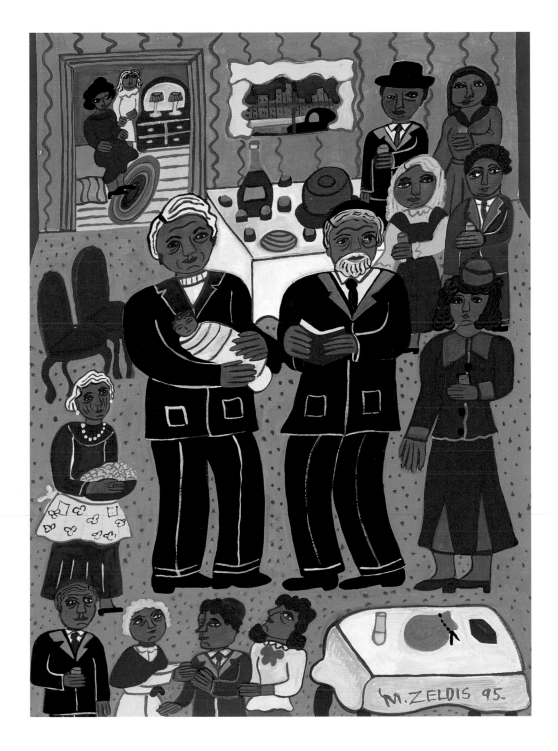

BAR AND BAT MITZVAH: JOINING THE FOLD

A Jewish boy's thirteenth birthday is an important milestone, for it is on this day that he becomes a man. This means that it is now his responsibility to carry out the *mitzvot*, or commandments. After months of preparation and study, he has his bar mitzvah, in which he is called to the Torah for the first time, where he reads a portion of the biblical text during synagogue services and in so doing, becomes an integral member of the community. Although most Orthodox Jews do not recognize the ritual passage of girls in the same way, many Reform and Conservative Jews have instituted the bat mitzvah for their daughters.

During the bar mitzvah ceremony, the young man acquires two important possessions symbolizing his commitment to Judaism: his *tallit* and his *tefillin* (two leather boxes enclosing passages from the Torah that are worn during morning prayer, except on Shabbat and festivals, and which symbolize his commitment to his faith).

The pair of images (on pages 80 and 81) B*ar Mitzvah* and B*at Mitzvah* show the young man (in his newly acquired prayer shawl) and the young woman, respectively, each reciting the passages from the Torah that he and she have laboriously prepared. Executed in similar palettes—raspberry, blue, lemon, and brown—these pictures possess a sweet, youthful lightness entirely congruent with their subject. The more densely patterned *Bar Mitzvah Service* shows a scene from the artist's childhood that takes place in the now-familiar *shul* of her grandfather, her father who appears at the upper left of the image.

Opposite: **BAR MITZVAH SERVICE**

78

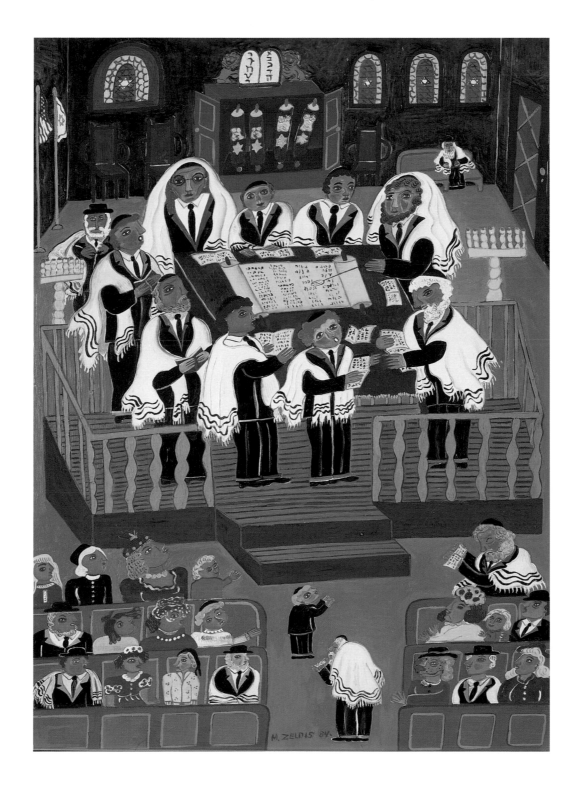

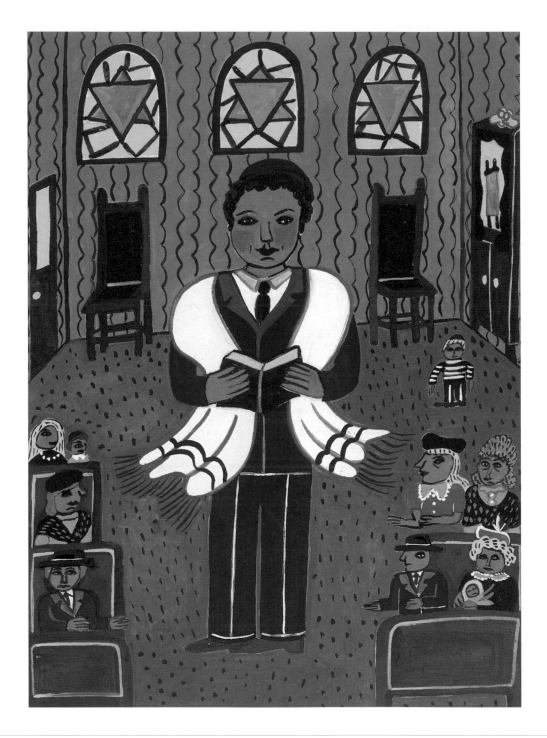

BAR MITZVAH

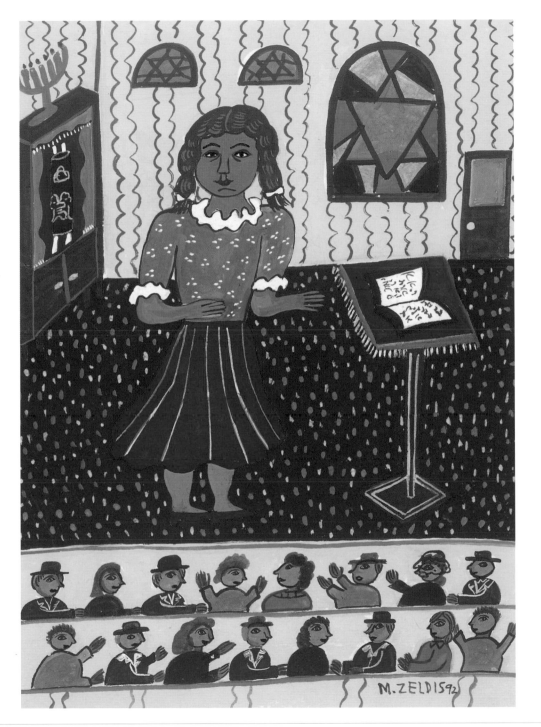

BAT MITZVAH

MARRIAGE: THE JOYFUL UNION

Marriage in the Jewish faith is more than the union of two individuals; it is considered the very foundation of society. At their wedding, the bride and groom symbolically establish a new household in Israel. There is even a Jewish mystical idea that a man is not considered human until he has been joined with a woman in matrimony.

Under the Chuppah depicts the moment when bride and groom have assembled with the rabbi under the traditional wedding canopy that symbolizes the bridal bower. In this case, the *chuppah* has been decorated with the Hebrew words *kol chatan, kol kalah*, which translate "the voice of the groom, the voice of the bride." Zeldis recalls that these words were sung at her own wedding, long ago in Detroit.

The ceremony is followed by a party, as seen in *Wedding Reception* (page 84). Here, the artist has re-created a typical banquet hall, the type in which generations of American Jews have celebrated their weddings. The guests who are not dancing in the center of the floor sit at long, U-shaped banquet tables. At the back, we see a forties-style band playing music; to its left is the mile-high wedding cake and an ice sculpture of a pair of lovebirds flanked by a Star of David. At the right is the *chuppah*, empty but still festooned with flowers. Altogether, it is a joyful scene that commemorates the blending of holy religious duty with earthly pleasures.

My Wedding (page 85) is the artist's own wedding portrait, painted to commemorate her marriage. Interestingly enough, however, it does not focus on the union of the bride and groom, but rather on the bride's parents, who are seen very prominently leading their daughter toward the *chuppah*. "There is a great emphasis on the family in the Jewish tradition," muses the artist. "The parents are seen as integral players in the wedding ceremony, and in the extended life of the couple."

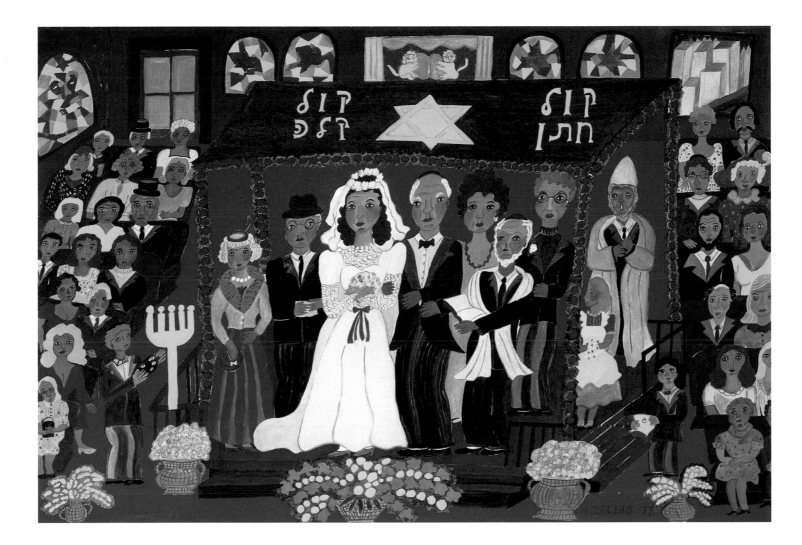

מזל טוב כלה

מזל טוב חתן

UNDER THE CHUPPAH

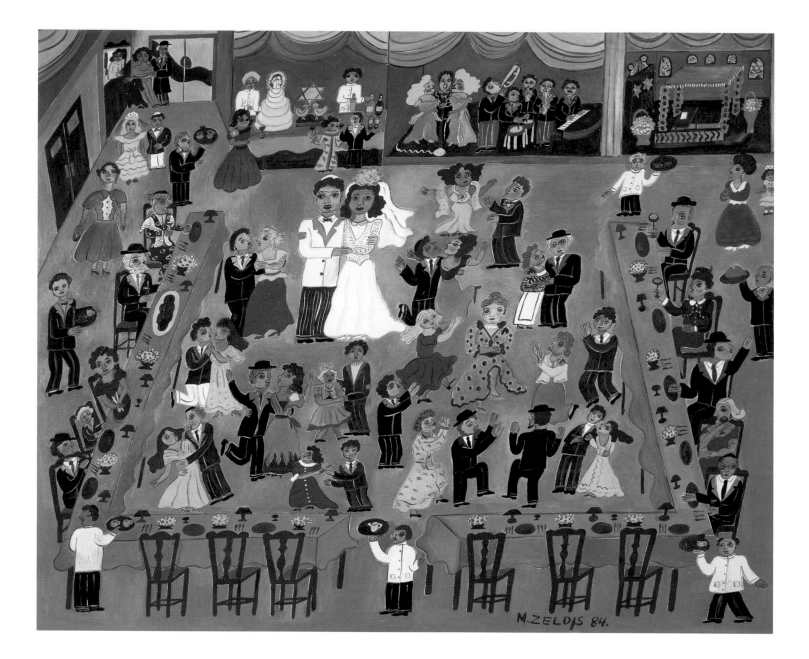

WEDDING RECEPTION

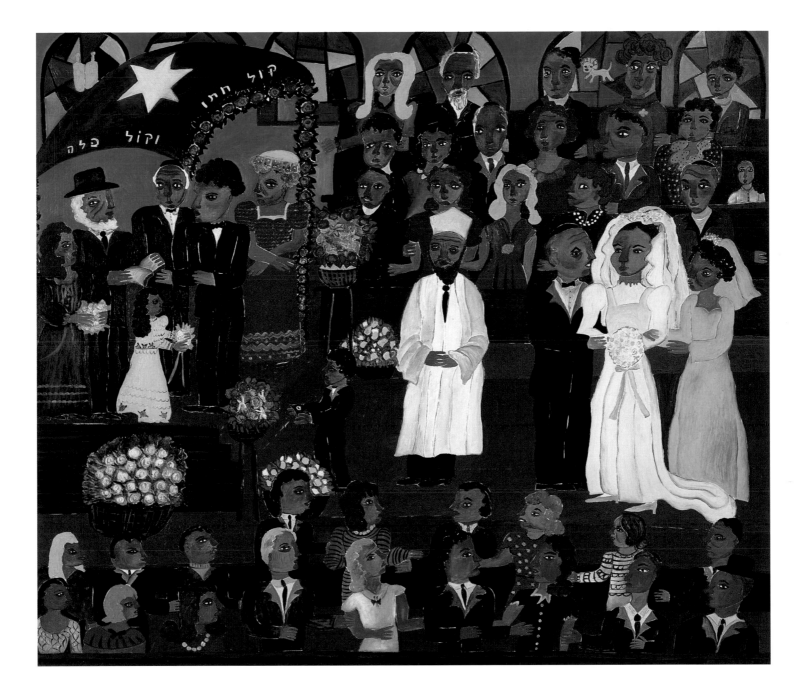

קול ששון וקול
שמחה וקול
חתן וקול כלה

Above: **MY WEDDING**

Overleaf: detail from **WEDDING RECEPTION**

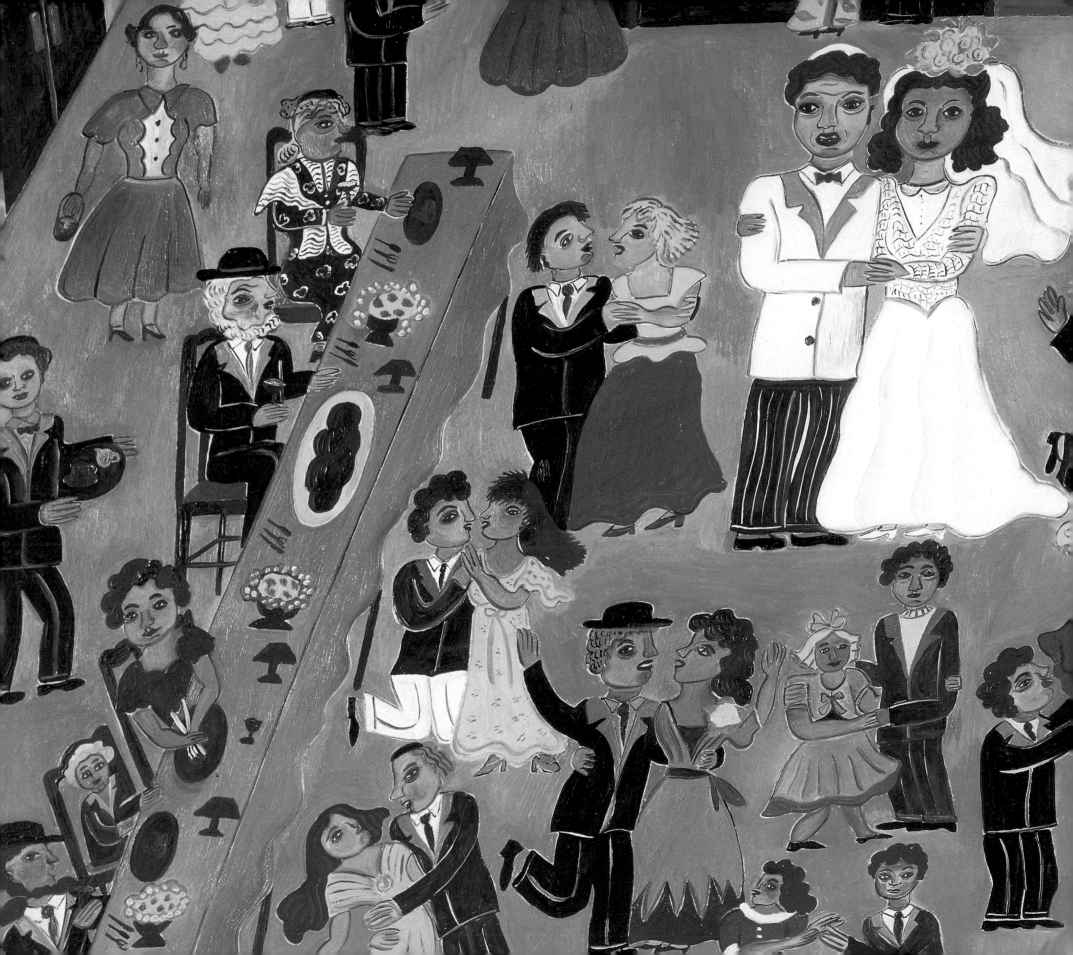

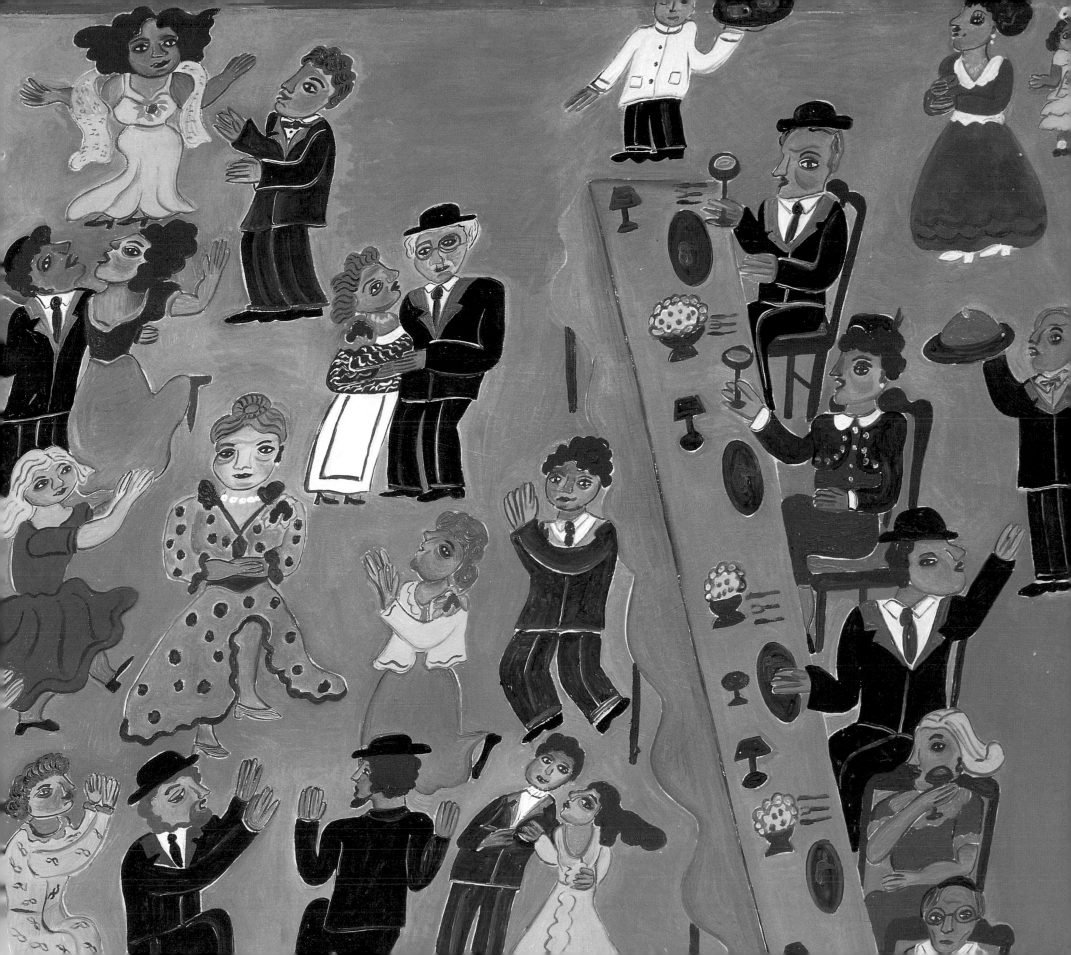

THE FINAL PASSAGE

Jews believe that the dead are entitled to respect and dignity. When a Jewish person dies, his or her sons recite a prayer (*Kaddish*) that is repeated during the period of mourning and on each anniversary of the burial. The mourning period has three distinct stages. First is *shivah* (Hebrew for "seven"), the traditional seven days of deep mourning, which begin immediately after the funeral. This is followed by two periods of modified mourning. After a year's time, all trappings of mourning are set aside.

Sitting Shivah depicts the first of these mourning periods; the painting's central group of men recite the *Kaddish* for the deceased, while other visitors offer their condolences to the bereaved family. The mirrors are covered, a long-held custom during this mourning time, and the members of the family sit on the traditional hard, cushionless seats—in this case, the small overturned orange crates scattered around the room.

The artist notes that this is once again her grandmother's house (seen often in her images) and that the painting depicts the period after her grandfather's death. The artist herself is not literally present in the image, because she was in Israel at that time. "But the painting is my way of commemorating his life and participating in the mourning that surrounded his death," she comments. With its deep, brooding greens and scarlets, it is indeed a somber image of the Jewish mourning process. But the animation of the scene, as well as the table of food at the upper left, suggests the hope and optimism of the Jewish faith that cannot be extinguished, even by the death of one its adherents.

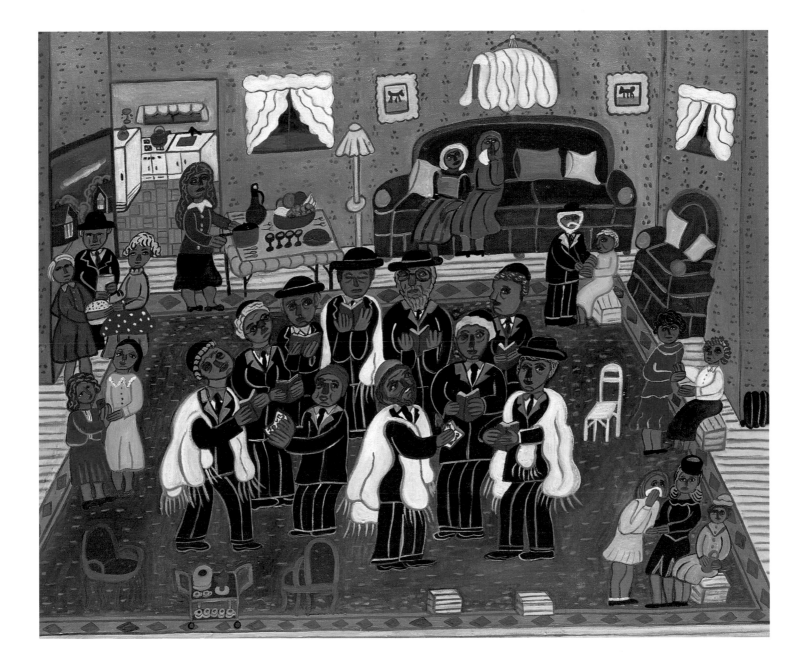

SITTING SHIVAH

ABOUT THE ARTIST

Malcah Zeldis is a self-taught painter whose family emigrated from Russia to America. Born in New York in 1931, she grew up in Detroit, lived for many years in Israel, and resides today in New York. Her paintings are housed in the permanent collections of numerous prestigious museums throughout the world, including the Museum of American Folk Art in New York City. Her work has been featured in more than seventy exhibitions and has received numerous awards. Malcah is the illustrator of several children's books, including *Eve and Her Sisters: Women of the Old Testament*, *Martin Luther King*, and *Honest Abe*.

ABOUT THE AUTHOR

Born in Israel, Yona Zeldis McDonough was educated at Vassar College and Columbia University. Yona is a widely published writer of both journalism and fiction, whose work has appeared in *Harper's Bazaar*, *The New York Times*, *Family Circle*, and other publications. She is also the author of several books, including *Eve and Her Sisters: Women of the Old Testament*, on which she collaborated with her mother. Yona lives in Brooklyn with her husband and their two children.

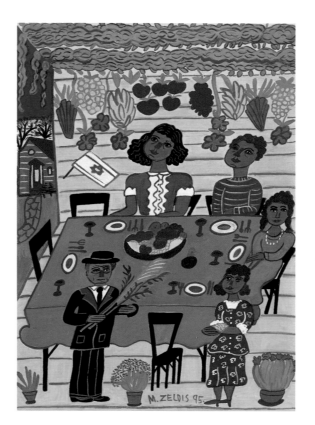